British
Contemporary
Art 1910-1990

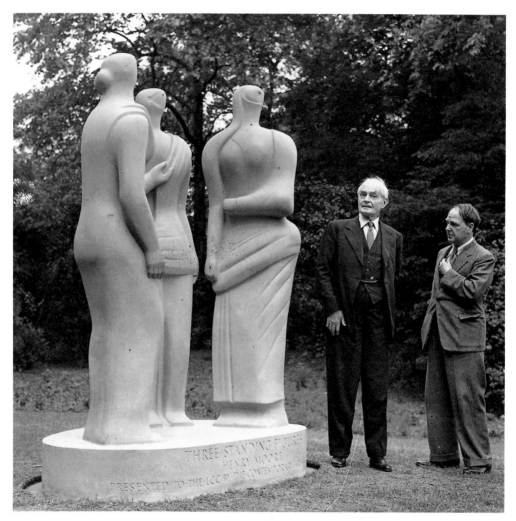

Sir Edward Marsh and Henry Moore at the unveiling in Battersea Park of *Three Standing Figures* by Henry Moore, presented to London County Council by the CAS, 1948

Alan Bowness
Judith Collins
Richard Cork
Joseph Darracott
Margaret Garlake
Edward Lucie-Smith
Frances Spalding
Marina Vaizey

British Contemporary Art 1910-1990

Eighty years of collecting by
The Contemporary Art Society

The Herbert Press

Copyright © 1991
The Herbert Press Limited
The Contemporary Art Society

Copyright in the text © 1991 by the individual authors
Copyright under the Berne Convention

First published in Great Britain 1991 by
The Herbert Press Ltd, 46 Northchurch Road, London N1 4EJ
in association with The Contemporary Art Society

Designed by Pauline Harrison
House Editor: Julia MacKenzie

Typeset in Joanna Roman
by Nene Phototypesetters Ltd, Northampton

Printed and bound in Hong Kong
by South China Printing Company (1988) Ltd

A CIP catalogue record for this book is available
from the British Library.

ISBN 1–871569–39–7

The Contemporary Art Society would like to thank
Rank Xerox (UK) Ltd for their encouragement and support.

Contents

To help find information.
On where people
get their inspiration
from.

To help find out
what other work
were about when
Richard Hamilton did his
collage.

Foreword

Throughout most of this century the Contemporary Art Society has been actively going about its business, trawling the art world, seeking out the important and relevant from the minor and mediocre. Many of the works and artists selected have gone on to attain 'icon' status, as a quick browse through this book will testify.

It is this which first attracted me to the Contemporary Art Society because there seemed a common thread linking them and Rank Xerox, both pathfinders in their respective fields. While the Contemporary Art Society has been pre-eminent as a guiding light in the art world, Rank Xerox has been similarly acknowledged as a beacon in the field of office technology.

The Contemporary Art Society in its role of developing contemporary art has supported and helped to establish many now household names, such as Henry Moore, Francis Bacon, Eduardo Paolozzi and David Hockney. In a similar way Xerox, from its research centre in Palo Alto, California, has developed most of the high technology products found in the office today, such as the laser printer, the personal network computer, the graphical user interface, the Ethernet network system and the first commercial fax machine. Today the emphasis is on bringing colour to the document and providing easier ways to produce better documents.

The Contemporary Art Society and Rank Xerox have both prospered because they are able courageously to support and develop their areas of art and technology. I commend this book and wish the project every success.

RANK XEROX

The Document Company

David Thompson
Chairman Rank Xerox (UK) Ltd

Introduction Alan Bowness

The eighty-year history of the Contemporary Art Society is one of the brighter spots in the British record of the patronage of modern art. In general, our support has been dismal, both for foreign innovation and for the more adventurous of our own artists. Those of us who served on the executive committee of the Contemporary Art Society (and I was a member for twenty-five years) have always realized the inadequacy of our task. But at least something has been done – and continues to be done – and when one reads the essays that follow and considers the acquisitions now scattered across the country and the Commonwealth one can recognize that this has been no mean achievement.

The intentions and procedures of the Contemporary Art Society have changed little since its formation in 1910. It was founded by a group of enthusiasts who wanted to do for contemporary art what the National Art-Collections Fund had recently begun to do for art of earlier periods. Paintings and sculptures, not more than twenty years old, were to be acquired, exhibited as widely as possible, and then presented to national and municipal collections. Funds were to come from these municipal galleries, in expectation of receiving gifts of modern works of art, and from individual subscribers, the more active of whom were always to form the Society's executive committee.

As Judith Collins's essay makes clear, the dominant members of the original committee were D. S. MacColl and Roger Fry. MacColl was a painter and critic who was also Keeper of the newly established Tate Gallery from 1906 to 1911. The Tate was at that time exclusively concerned with British art, and MacColl thought highly of current production. He could get his Wilson Steers through the NACF, but he needed a new body if he was to obtain work by the younger artists whom he admired – Augustus and Gwen John, William Nicholson, Jacob Epstein and Eric Gill.

Fry, by now celebrated as a champion of modern art and notorious as the organizer of the Post-Impressionist exhibitions, was anxious to promote the younger painters, particularly his friends, Vanessa Bell and Duncan Grant. He also thought the Contemporary Art Society should be buying modern foreign art, and one of the first acquisitions was the unfinished Gauguin, *Tahitians*, now in the

Tate, which Fry bought for £30 at the 1910 Post-Impressionist exhibition and seems to have given at once to the new Contemporary Art Society (henceforward abbreviated to CAS).

All these early acquisitions were held by the CAS for a period of time, as if to test their staying power before they were handed on to public galleries. This has remained the practice, and from time to time works have been sold or exchanged. Generous gifts were being made to the Society from the very beginning, and the usefulness of such a conduit to potential donors is one of the reasons why the CAS has survived to the present day.

The Gauguin and many of the early British acquisitions, including Augustus John's *The Smiling Woman*, were handed over to the Tate in 1917 when it was reconstituted in its dual capacity as the National Gallery of British Art, with special responsibility for modern British art, and for the first time as the National Gallery of Modern Foreign Art. The special relationship between the Tate and the CAS has persisted until this day. Housed as a 'grace and favour' resident on Tate property, the CAS was until 1946 run by young Tate curators such as H. S. Ede and Robin Ironside, who acted as its Assistant Secretary. At this period the Tate had no government grant, and the acquisition of modern art had to be financed out of small private funds. The most important of these was the Chantrey Bequest, controlled by the President and Council of the Royal Academy. Chantrey taste was, inevitably, conservative, and it was left to the CAS to see that some more adventurous work by British artists came into the Tate collection. In the 1920s this meant mainly Camden Town and Bloomsbury painting and the artists who showed with the London Group. Wyndham Lewis was too uncomfortable a painter to win CAS patronage, though as Richard Cork points out on page 52 the presentation of Nevinson's *La Mitrailleuse* to the Tate as part of the original 1917 gift was perhaps the boldest gesture in the Society's history.

There is a certain cosy complacency about the CAS's activities between the wars, perhaps exemplified by the patronage of Edward Marsh who was the Chairman from 1936 to 1952. He was enormously generous and devoted to the CAS, and his bequest in 1953 of nearly 200 paintings, drawings and sculptures is the largest the Society has received to date. I remember visiting him when I was a Cambridge undergraduate in the early 1950s and being astonished by the way he had filled his small house in Chelsea with pictures hung from floor to ceiling on every wall space – exactly as Paul Nash had described it nearly forty years earlier. All this came to the CAS and enriched a hundred galleries.

Marsh owned no foreign art, and he was too old to appreciate the abstraction and surrealism that characterized the more advanced British art of

the 1930s. This was not a good period for the CAS. Dominated by a clique of well-meaning patricians – Lord Howard de Walden, the Earl of Sandwich and Lord Ivor Spencer-Churchill among them, membership was only a little over 500 in 1936. As Frances Spalding tells us in her article, the enlightened and wealthy painter Edward Wadsworth resigned his membership in disappointment in 1931, and when new, young collectors such as Helen Sutherland appeared on the scene their offers to present the Society with paintings by a younger generation were discouraged and then not repeated.

Frances Spalding also explains the special help that was given at this time to the Department of Prints and Drawings at the British Museum, and the reasons for the establishment of a Foreign Fund in 1925. The question of acquiring work by non-British artists has been – and remains – something of a problem for the CAS. The funds at the Society's disposal have always been small, and never large enough to do any serious purchasing abroad. Between the wars the policy seems to have been to buy a few examples for the two national collections, the Tate and the British Museum. Something is better than nothing, and Rouault's *La Mariée* is a great painting, and there are wonderful Bonnards and Vuillards in the Tate that came from or via the CAS. But with artists a little more modern the CAS faltered. The only Picasso painting the CAS ever purchased was the feeble and uncharacteristic *Flowerpiece* of 1901, which was acquired in 1933. Roger Fry must sometimes have been exasperated by the timidity of his fellow committee members: he kept on trying to get them to buy Matisse, but when the CAS approached the artist in 1926 asking for a work for the national collection they returned with the modest and undemanding 1921 painting of the *Liseuse à l'ombrelle*. What masterpieces could have been obtained for the same price! But then one has to remember that the Trustees of the Tate Gallery turned down the *Liseuse* when it was first offered to them in 1929, and only accepted it eight years later. (The longest delay of this kind occurred with the George Grosz watercolour of *A Married Couple*, which was given to the CAS by the art dealer Alfred Flechtheim in 1936 but did not enter the Tate collection until 1955.)

I suspect that the CAS might not have survived World War II had it not been for the presence of the young and energetic Kenneth Clark on the committee. Certainly his taste in British contemporary art dominates the acquisitions of the 1940s, and his personal generosity to the Society was considerable. It was in this way that major examples of the work of the Euston Road painters (Victor Pasmore, Graham Bell, William Coldstream, Lawrence Gowing) and the Neo-Romantics (John Piper, Graham Sutherland, John Minton, John Craxton) were acquired at an early date. Others of Clark's generation also contributed. The support of Robert Sainsbury and the presence of Colin Anderson on the

committee help explain why Francis Bacon was bought in 1946 and 1949, before his prices began to escalate. The sharply rising prices of successful artists have always been a problem for the CAS, as for any collector short of millionaire status.

In the years immediately after World War II the art scene was changing, especially with the acceptance of the principle that state-provided funds should be used to acquire works by living British artists. The Tate Gallery received its first grant-in-aid in 1946: only £2,000 per annum, but slowly rising to £40,000 in 1959, £265,000 by 1970 and £2 million in 1980, since when it has declined in real terms. Of course these very large sums were always used for more than contemporary art, but they nevertheless meant that the help historically provided by the CAS was no longer essential to the Tate Gallery. Because of the support the Tate Gallery has continued to give the Society there has been an informal agreement that the Tate will occasionally ask for works in the possession of the CAS when they fill a gap in the national collections. Otherwise major acquisitions go elsewhere.

More important perhaps has been the patronage of the Arts Council, exercised exclusively towards living British artists. This began in 1942, when the Council for the Encouragement of Music and the Arts began to buy British painting and sculpture to form touring exhibitions – very much the same motivation that had led to the formation of the CAS in 1910. CEMA became the Arts Council in 1946, and this missionary work has continued. The sum allocated for purchasing grew between 1944 and 1959 from £2,000 to £4,000, rising to £21,000 by 1970 and £74,000 in 1978. Like the Tate acquisition funds this too declined in the 1980s, but it was always substantially more than the CAS ever had to spend.

In these circumstances the CAS had to change too. The number of member galleries had grown steadily in the 1930s, and now included art museums in the Commonwealth, especially in Canada, Australia and New Zealand. They were grateful for gifts of contemporary British art, and the artists were helped by wider exposure. It was in this spirit that the CAS made some gifts to the United States, most notably in 1940 when Stanley Spencer's *The Nursery* (seen in the 1991 Barbican exhibition) was presented to the Museum of Modern Art in New York.

This policy has not been pursued, partly because it overlaps with the work done by the Fine (now the Visual) Arts Department of the British Council. Their permanent collection, like that of the Arts Council, grew rapidly in the 1940s and 1950s, and exclusively focused on contemporary British art. And then in 1947, with the formation of the Institute of Contemporary Arts under the patronage of Peter Watson, Roland Penrose and Herbert Read, another body appeared on the scene, which inevitably was to affect the work of the CAS.

Towards the end of the war the committee under the chairmanship of Edward Marsh decided that a paid part-time assistant secretary was necessary if the Society was to survive. The choice fell on the painter, Denis Mathews, then in his early thirties. He was to remain with the CAS until 1956. He was succeeded by Pauline Vogelpoel who was Organizing Secretary until 1982, when she was in turn followed by Petronilla Silver, now styled the Executive Director. The Society has been very fortunate in its chief officers, and without them would never have flourished: to have had only three in almost fifty years is a testimony to their dedication and personal loyalty.

Denis Mathews did two important things: he initiated a programme of exhibitions at the Tate Gallery, and he fostered the individual membership by providing social occasions, such as private views and visits to collections at home and abroad. Something was done again to encourage the idea of collecting modern art.

Joseph Darracott writes about the CAS exhibitions on pages 75–6. They were put on at a time when the Tate itself promoted no exhibitions but provided gallery space for the Arts Council's Art Department. The CAS contributed to the programme, emphasizing its particular interest in collecting ('Seventeen Collectors' 1952) and in contemporary British art ('Figures in their Setting' 1953, 'The Seasons' 1956 and 'The Religious Theme' 1958). These were important exhibitions, providing a survey of the state of British painting and sculpture, and they culminated in the very successful 'British Painting in the Sixties' (at the Tate and Whitechapel in 1963 and then toured at home and abroad) and 'British Sculpture in the Sixties' which followed in 1965. From all exhibitions, significant purchases were made by the Society, for example William Scott's *Winter Still Life* and David Hockney's *The Marriage of Styles No. 2*.

Despite their popularity and critical acclaim these exhibitions were not followed up, for a number of reasons. Their organization stretched the resources of a small voluntary society in an unacceptable way, and once again the CAS was overtaken by state-supported bodies such as the Tate, which set up its own exhibition department in 1968, and the Arts Council which opened the Hayward Gallery in the same year. The Hayward exhibitions of contemporary British art from the mid 1970s onwards followed the CAS's lead.

Something similar happened with the social activities arranged for members by Denis Mathews, because here the CAS set the pattern for the Friends' organizations that almost every museum and gallery now finds it valuable to have. At first membership prospered, rising spectacularly from 300 in 1946 to 1750 in 1953, but success stimulated emulation, and in particular the foundation of the Friends of the Tate Gallery in May 1958 affected the role of the CAS. The

Friends of the Tate at first had a much higher subscription, and the two organizations have lived together amicably enough, but the special relationship which the CAS has had with the Tate from its inauguration was inevitably transformed.

I had joined the CAS as an ordinary member in 1956 and was elected to the executive committee in 1961, partly I think to help with the 'British Painting in the Sixties' exhibition and then 'British Sculpture'. At that time Whitney Straight was the Chairman and Peter Meyer Treasurer of the Society. We met four or five times a year in the Tate's boardroom: Pauline Vogelpoel's office was a tiny cubbyhole close to the side-door entrance of the Tate, much too small for meetings. The committee was about fifteen strong, mainly private collectors of recent British art but with a few 'professionals' – gallery directors and art critics such as Loraine Conran, Bryan Robertson and myself. Each year two of us were invited to be the Society's purchasers. It was believed to be a firm principle that the CAS had always avoided committee taste, with the compromises that tend to result. Occasionally the purchases proved a disappointment, but normally the practice has worked well.

Every three or four years there was a distribution. The purchases were placed on exhibition, and directors of all the member galleries were invited to see them. They were asked to provide a list of preferences and then Pauline Vogelpoel went into purdah for a few days and worked out an allocation. She was brilliant at this: gallery directors were rarely disappointed, and normally felt that they had good value for their modest subscription. It was often a way they could get works into their collections that their committees might otherwise refuse. Though many directors were still a little timid and the more advanced works tended to go abroad, CAS donations were nevertheless the way in which many public collections of contemporary British art have been slowly built up in dozens of museums and galleries. This is particularly true of medium-sized galleries, all over the country.

Edward Lucie-Smith surveys the history of CAS acquisitions in his essay on pages 146–56. He is right to stress that the sum available to purchasers always seemed woefully small. I was first a purchaser in 1962 with I think £1,000 at my disposal. One was asked to buy a certain quantity of works – say twelve to fifteen – so that there would be something for all member galleries at the next distribution. There was a great burgeoning of new talent on the British art scene at that time, so I tried to be even-handed, buying Leon Kossoff as well as Bernard and Harold Cohen, John Hoyland as well as Allen Jones. I didn't buy Kitaj or Hockney, much as I admired their work. They quickly became too expensive for the CAS. With my fellow buyer, Lord Croft, we bought *March 1961*, the first major

Roger Hilton oil acquired by the Society. I bought Hilton again in 1972, when my turn as a purchaser came round once more. The allocation was now £2,000, more inadequate than ever when one was bidding for a dozen works. And some of the more daring purchases – Rita Donagh, John Walker, John Murphy – did not easily find homes in the member galleries.

My last round of purchasing before I left the committee was in 1981. Belle Shenkman and I divided the field, and I bought only sculpture (often rather neglected by CAS purchasers) and works on paper by non-British artists, thus reviving one of the particular fields of interest of the CAS between the wars. It was an exhilarating experience, and like every CAS buyer I felt both privileged and anxious to fulfil my responsibilities sensibly.

The acquisition and distribution to public galleries of works by living artists has been and remains the prime purpose of the Contemporary Art Society. Edward Lucie-Smith sees the 1950s and early 1960s as its golden age, and, like Margaret Garlake in her essay, comments on the crisis that faced the Society in the 1970s. The problem essentially was that necessary costs of administration were taking up an unacceptably large proportion of the Society's funds, and that its activities looked rather ineffectual at a moment when many of the member galleries were now actively buying contemporary art themselves. New initiatives, such as the presentation and installation of major sculptures in public places, which had begun well with the Henry Moore *Knife Edge – Two Piece* in 1967 (though the CAS has had little credit for this), ended in the fiasco of Philip King's *Span* which Margaret Garlake describes on page 111.

I must admit that I shared John Sainsbury's view in 1973 that perhaps the time had come for the CAS to wind up its activities and merge with the National Art-Collections Fund. Not all the committee members agreed, and in particular Nancy Balfour, who was to become Chairman from 1976 to 1982, fought for the Society's survival. The doubters were wrong. Nancy Balfour and her successor Caryl Hubbard, aided most effectively by the officers, Pauline Vogelpoel and Petronilla Silver, succeeded in turning the CAS into the flourishing organization that exists today. Broadly speaking, there are I think three reasons for the turn around in the Society's fortunes – the new corporate collecting of the 1980s, the invention of the annual CAS Market, and the provision of substantial acquisition funds from other institutions. You might also say that the CAS has marketed itself as an organization too useful to be allowed to disappear.

If we take the last factor first: results show that the CAS provides an excellent channel by which contemporary art reaches public collections. In its own purchasing activities, the Arts Council had learned from the CAS methods, and in 1974 gave £2,000 to the Society to be added to the sum available for purchasers.

This had increased to £5,000 in 1976, more than doubling the sum provided from the Society's own funds.

In 1977 the Scottish Arts Council gave the CAS £1,000 to buy work by Scottish artists, to be included in the general distribution. This was a way of ensuring that Scottish artists would be better represented in UK and Commonwealth collections. In 1983 when the CAS once again, under the influence of Ann Sutton, began buying crafts, the Crafts Council provided the Society with an annual grant of £4,000. And in the same year, the Henry Moore Foundation began to give the CAS an annual grant to buy works of sculpture. Not all these grants have continued – though the Henry Moore Foundation are now providing £40,000 – but they have helped multiply the sums available for acquisition very considerably.

Corporate patronage also began in the 1970s. Here the Society was able to build up an impressive list of corporate members, and, in certain cases, offer its own expertise in helping members to build up their own collection. This began with Mobil and De Beers, and had the beneficial effects of both earning fees for the Society and helping the artists whose work was bought. In similar fashion, the annual art market began rather tentatively at first, but with Sainsbury's patronage has grown to be an enormously successful annual occasion with a turnover of over £320,000 in 1990. Artists are assisted, collecting is encouraged and the CAS helps to earn its keep, and now provides its two buyers with £45,000 each per annum.

Marina Vaizey's essay underlines the enormous expansion that has transformed the art scene in the 1980s. Thanks to these and other new initiatives the CAS has adapted itself and flourished, surviving to celebrate in some style eighty years of active patronage of modern art. The essays that follow take the story further and in many different directions. On one thing however we are all agreed. There can be no doubt of the contribution made by the Contemporary Art Society to British art in this century.

The origins and aims of the Contemporary Art Society
Judith Collins

On 9 April 1909 seven prominent figures in the British art world met at 44 Bedford Square, London, the home of Philip Morrell, a Liberal Member of Parliament, to discuss forming a committee which would purchase and exhibit the best of contemporary British art. The seven were Morrell, his wife Lady Ottoline; D. S. MacColl, a painter, art critic, and Keeper of the Tate Gallery since 1906; Charles J. Holmes, a painter, art critic, and newly appointed Director of the National Portrait Gallery; Roger Fry, a painter, writer and lecturer on art, and Curator of the Metropolitan Museum of Art, New York; Ernest Marsh, an expert on Martinware pottery; and Charles Aitken, Director of the Whitechapel Art Gallery. On that day, the seven 'resolved themselves into the provisional committee for a new Modern Art Association' and decided to ask three more people to join them. The extra three were Arthur Clutton-Brock, art critic of *The Times*; J. Bowyer Nichols, poet and writer on art; and Robert Ross, Director of the Carfax Gallery.

 Why did these people believe that in 1909 the formation of a 'Modern Art Association' was necessary, and why were they committed to bringing it into existence? Ottoline Morrell recorded in her diary that after lunch the group went on to the Tate Gallery to see the Alfred Stevens drawings that MacColl had recently acquired for the national collections. Stevens was a High Victorian artist who died in 1875 and Ottoline described him as 'one of the few Englishmen with real direct genius – he and Blake and Turner'. Her diary continued:

How hard it is for any genius to get on or to live!
 I feel strongly now that every penny one can save ought to be given to young artists. At least, we who really feel the beauty and wonder of Art ought to help them. There are heaps of people who understand philanthropy and who can help it, but so few can hear the cry of pure Art … And young creators have such a terrible struggle.

Ottoline Morrell had already begun to put her pennies where her heart lay by collecting the work of young British artists such as Augustus John, Charles Conder and Jacob Epstein. However, her friends in high places in major art galleries began to realize that enthusiastic private patronage would not be enough to support young British artists. A national organization was required.

[15]

In 1903 The National Art-Collections Fund had been formed to assist in the purchase of works of art for British public galleries, but it came into being mainly as a response to the large number of important old master paintings, sculpture and pieces of historic furniture that were being sold off by private collectors in country houses. It was hoped that the NACF would help in preventing the sale of British heritage items to overseas buyers by offering funds which would supplement the meagre grants of the British national and provincial museums and galleries. Because the NACF monies were primarily directed at acquiring for the public collections paintings and sculpture that, in some cases, had been in this country for centuries or many decades at least, it was not capable of giving the highest priority to the purchase of contemporary art. It did not entirely neglect this area though, because it believed it had a duty to make the national collections as representative as possible. Not surprisingly, given their keenly developed sense of service towards the art world in Britain, both D. S. MacColl and Roger Fry were instrumental in the founding of the NACF in 1903. And when they worked together a few years later to set up the CAS, they, along with Holmes, Morrell and Aitken, convened a meeting in April 1910 with the NACF committee to sort out the relative intentions of both societies. The CAS

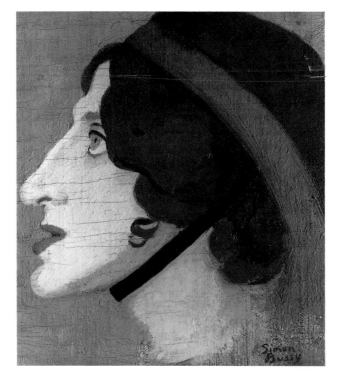

Simon Bussy 1870–1954
Lady Ottoline Morrell c.1920
oil on canvas, 31.8 × 29.2 cm
presented by Clive Bell and
Duncan Grant to the Tate
Gallery, London, 1951

pronounced that it would 'work in friendly co-operation with the NACF' and in order to keep good communications between the two societies, a handful of people served on both committees for a while.

During April and May 1910 the committee members of the CAS, still then known as the Modern Art Association, met three times to work out their policy. By 18 May, the name of the Contemporary Art Society had been settled upon, and also a policy of supporting modern artists of all nationalities, not just British ones. From the ten members of the committee, three were nominated to choose the first purchases, and they were MacColl, Fry and Robert Ross. They served until November 1911, when it was decided at a meeting that purchase by a committee was to be avoided, and that the year's acquisition funds would be handed over to two individuals, who, for six months each, would have a completely free rein to purchase whatever they chose. Membership of the CAS was set at an annual subscription of one guinea, although it is likely that committee members and their friends dug deeper into their pockets. In the first annual report of the CAS, published in 1912, 141 private subscribers are listed as members, along with three forward-looking municipal corporations – Belfast, Leicester and Manchester. This annual report contains the first official published manifesto of the Society and it makes interesting reading:

From the conviction that some of the finer artistic talent of our time is imperfectly or not at all represented in the National and Municipal Galleries, the CAS was initiated in the year 1909. Its aim is to encourage by purchase and exhibition the more remarkable examples of painters who in any other country would enjoy a certain official patronage. During the last century little or no attempt was made to secure for the nation any vital contemporary painting which has stood the test of time. It is almost entirely due to private munificence and foresight that Alfred Stevens, the Pre-Raphaelites, and the Impressionists are represented at all in the National Collections or in Municipal Galleries. The CAS hopes to obviate a similar reproach being made against the present age. The Committee, on which are represented widely different opinions, believes that with the exercise of discrimination pictures by contemporary artists should be purchased in order to supply what may seem to posterity an inexcusable gap in our public museums and galleries, already overloaded with ephemeral work of the age preceding our own. The scope of the Society is limited to Artists living or recently dead, and is chiefly concerned with British Art; but it is open to Subscribers to allocate the whole or any part of their subscriptions to a separate fund for acquiring the works of foreign Artists. The Society will, for the present, remain the legal owners of the works it acquires; and will lend them for exhibition to various galleries in turn, rather than offer them as absolute gifts.

Three interesting areas emerge from this text; firstly, no mention of, or support for, sculpture is included even though some had already been bought; secondly,

the decision whether or not to purchase work by foreign artists is placed in limbo; and thirdly, much criticism is directed at acquisitions of 'ephemeral' work executed by artists of the preceding generation.

The latter criticism had already been voiced by MacColl and Fry as early as 1904 when both men gave evidence to the Select Committee of the House of Lords enquiry into the administration of the Chantrey Bequest. Sir Francis Chantrey, a successful nineteenth-century British sculptor and Royal Academician, left on his death £108,000 invested in a trust fund for the purchase of 'works of Fine Art of the highest merit in painting or sculpture … executed by Artists of any nation provided … the same shall have been entirely executed within the shores of Great Britain'. The bequest was to be administered by the President and Council of the Royal Academy, who were also to provide the officers responsible for the selection of the purchases. The resulting acquisitions were to form the basis of a 'public national collection' although Chantrey left no money for a building to house such works. The first purchases of the Chantrey Bequest were made in 1877 and were housed in the Victoria and Albert Museum, then called the South Kensington Museum, as well as being loaned to some regional galleries. When the Tate Gallery opened in 1897, the Chantrey Bequest purchases were transferred to Millbank, where they occupied several rooms and quite dominated the Tate's embryonic collections. Since the Tate Gallery had no purchase grant of its own, at least the Chantrey works provided something for the public to look at. But criticisms began to grow about the quality of work chosen for purchase with Chantrey money, and it must have been gratifying to detractors, foremost among which were Fry and MacColl, when in 1904 the House of Lords held a debate on this issue. Fry and MacColl felt that the President and Council of the Royal Academy had diverted Chantrey money into the exclusive purchase of works by inferior Royal Academicians, and had not looked outside the portals of their institution at the younger British artists, such as Charles Conder, Philip Wilson Steer, William Rothenstein and Augustus John, who were making works of higher merit. As a result, Fry and MacColl believed that an annual purchase fund of about £2,000, the principal endowment in Britain for the purchase of contemporary art, was being squandered by Academicians upon Academicians. It must have served to strengthen their resolve that something had to be done in Britain to provide public patronage for young talented artists.

MacColl acknowledged that what brought matters 'to a head' in the formation of the CAS was the sight of Augustus John's painting, *Woman Smiling* (now known as *The Smiling Woman*), in an exhibition entitled 'Fair Women', which was organized by the International Society of Sculptors, Painters and Gravers and

held at the New Gallery, Regent Street, London during February and March 1909. Both C. J. Holmes and Roger Fry reviewed the 'Fair Women' exhibition for the same issue of the *Burlington Magazine*, April 1909, and both paid excessive attention to John's picture. Holmes and Fry compared John's painting with Botticelli, the Pollaiuoli, Andrea del Castagno and Francesco del Cossa, in the hope that the intelligent readers of the *Burlington Magazine* would form the opinion that John was the natural descendant of a great artistic tradition. From this standpoint, it would be obvious that John should be patronized and given important public commissions which would place his work firmly in the public eye.

A private patron, Dr C. Bakker, bought *Woman Smiling* from the 'Fair Women' exhibition and the 'formidable picture' was removed from public view. It was next seen again in a loan exhibition of John's work at Manchester City Art Gallery in September 1910. At the sixth meeting of the committee of the CAS held on 19 October 1910, Robert Ross informed those present that the selection committee, consisting of himself, MacColl and Fry, had purchased John's *Woman Smiling* for the sum of £225, even though they only had £150 at their disposal. It thus became the first ever purchase by the CAS, a most apposite state of affairs since the painting had largely been responsible for galvanizing its admirers into philanthropic action and the formation of the Society. It was lent by the CAS to a 'Loan Collection of Modern Paintings' held at the Laing Art Gallery, Newcastle upon Tyne, in October 1912, and it was given by the CAS to the Tate Gallery in 1917, making it the first painting by Augustus John to enter the national collections.

The chief aim of the CAS, as stated in its first annual report, was 'to encourage by purchase and exhibition' and the officers of the committee were most diligent in the encouragement and organization of exhibitions of recent British art throughout the length and breadth of the country during the first two years of the Society's existence. Because the CAS purchases only totalled about eighteen oil paintings and twenty or so watercolours and drawings in those early years, they were not enough to form an exhibition unaided, but members of the CAS committee and their colleagues lent works of a similar kind to bring the total up to about eighty. Exhibitions were part of the proselytizing and didactic side of the CAS. It was not enough to patronize a young artist just by purchase. His work then had to be seen regularly and discussed. The committee members of the CAS made it their business to give a public lecture at the opening of these loan exhibitions and these drew much interest, often being reported in the local press.

The first time the CAS lent some of its new purchases to an exhibition was to one organized at Kingston-on-Thames, a municipal art gallery with which Ernest Marsh had close connections, being an eminent member of Kingston's Library

and Museum Committee. The exhibition opened on 1 July 1911 and ran until 16 September, during which time John's *Woman Smiling* was accompanied by *An Interior* by Gwen John, *The Chintz Couch* by Ethel Sands, *Portrait of George Moore* by Walter Sickert, *The Lowestoft Bowl* by William Nicholson and *The Green Apple* by Charles Conder, all recent CAS purchases. After Kingston, works were loaned to Burnley Art Gallery in the autumn and to a significant exhibition at Manchester City Art Gallery during December 1911 and January 1912. Then throughout 1912 there followed loans to Rochdale Art Gallery, the Sandon Studios in Liverpool, Leeds, Aberdeen, Bradford, Newcastle and Leicester. The Leeds exhibition was opened with a lecture by Charles Aitken and the Newcastle with the same by Robert Ross. Attendances were recorded in some cases, with over 45,000 visitors at Manchester, over 30,000 at Leeds, 9,500 at Aberdeen and around 30,000 at Bradford. CAS pictures were even sent to an exhibition of British paintings at Zurich Art Gallery in 1918. Sending the new CAS purchases out on tour obviated the need to find and maintain a store for them and it is not recorded in any of the early literature where CAS works were housed when not on loan. Because MacColl was Keeper of the Tate Gallery until 1911, when his post was taken by Charles Aitken, there was, in these formative years, a strong connection between the CAS and the Tate, and it is assumed that the Tate Gallery provided storage space for CAS purchases from the very beginning.

The catalogue published to accompany the loan exhibition held at Manchester City Art Gallery which opened in December 1911 contained an essay by D. S. MacColl entitled 'The Origins and Aims of the Contemporary Art Society'. In this essay MacColl explained how useful it was for new CAS purchases to remain the property of the Society until such time as they were readily accepted by a new audience: 'It seemed to be necessary to establish some half-way house, some place of suspense, which the more courageous lovers of the arts, admirers of living as well as dead artists, might fill with their works, and hold them until more timid people were sure of their ground.' MacColl included the Trustees of the Tate Gallery among the timid and recounted how he had experienced difficulties, when Keeper of the Tate, not only in finding some money for purchases but also in persuading his Trustees to accept these acquisitions for the national collections. In 1922 when MacColl looked back on his years as a professional art administrator in his book *Confessions of a Keeper*, he still felt strongly about his half-way house notion and produced these stirring words:

What is wanted is an intermediary, a suspended state of being or probation, a Purgatory of art before the Paradise of national collections is reached. And two such purgatories were provided at a time when it was not always possible to force good things into the National

[20]

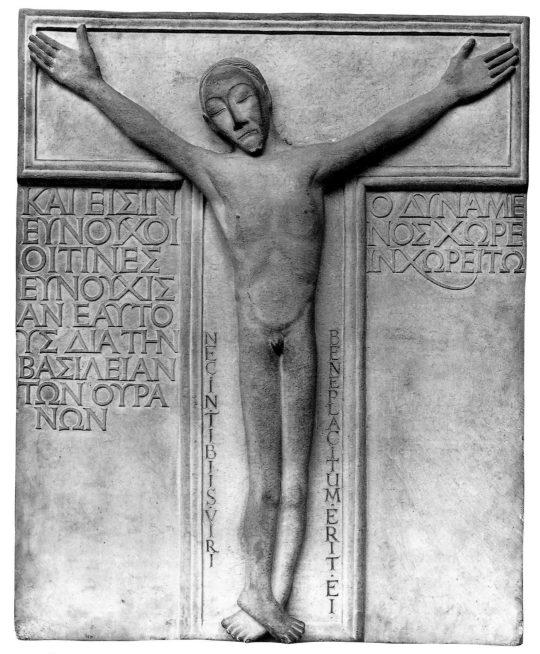

Eric Gill 1882–1940
Crucifixion 1910
Hoptonwood stone relief, 94.5 × 78 × 13 cm
purchased by Roger Fry and Robert Ross, 1911
presented to the Tate Gallery, London, 1920

or Tate Gallery. One is the National Art-Collections Fund, predominantly but not entirely for Old Masters; the other the less wealthy and powerful Contemporary Art Society, entirely for the living. If benefactors would be content to give or leave to those societies for a term of probation, and greater power were given to the galleries to dispose of works coming from the Chantrey and other sources, we should have some mitigation of an excessive hospitality.

Two pieces of sculpture purchased by Ross and Fry for the CAS in January 1911 had to serve a probationary period of a few years while public taste became accustomed to them. In January 1911 Eric Gill held his first exhibition of carved stone sculpture at the Chenil Gallery, Kings Road, London, and Ross and Fry bought the two stone reliefs, one of Christ crucified and the other of a naked woman, which had excited the most critical comments of all the works on show. The crucifixion relief was shown in CAS regional exhibitions at Manchester and Newcastle. But when the CAS organized their first London exhibition, at the Goupil Gallery, 1–12 April 1913, Gill's two reliefs were not put before the London public. Randall Davies, the art critic of the *Pall Mall Gazette*, stressed in his review of the exhibition that the purchase of extremely modern works could lose the CAS some of its support, both moral and financial, and that the Society had to be both bold and yet tread carefully. He then continued:

In the early days of its existence the Contemporary Art Society made a regrettable blunder in acquiring two rather objectionable pieces of sculpture, which made a good many people withhold their support. The fact that these two reliefs are not included in the present show may be taken to indicate that the committee have recognized their mistake and will act in future with a little more caution.

Gill's crucifixion relief was given by the CAS to the Tate Gallery in 1920 and was the first work by Gill to enter the national collections. The other relief of the naked woman was given to the University of Hull Art Collection in the 1950s.

Randall Davies was right in stating that the CAS had to be both bold and careful. He was wrong in believing the CAS made 'a regrettable blunder' with these two purchases. Indeed, in the early and heroic years of the CAS, the Society and its officers appear to have maintained the highest aesthetic standards in all that they executed, which makes them an exemplary act to follow.

Allies of the Avant-Garde: Patrons of advanced art in Britain, 1910–1920
Richard Cork

Soon after World War I broke out, Wyndham Lewis trained his formidable battery of invective skills on Britain's unwillingness to support innovative art with the enthusiasm and largesse he would have liked. In the second issue of *Blast*, published in July 1915 to consolidate the eruptive emergence of the Vorticist movement, he railed at 'the lethargy, common and impermeably practical spirit that is the curse of this country'. Most of the work produced by the Vorticists remained unsold, and Lewis dismissed all thought of hoping that 'after the War England will change her skin so much that she will become a wise and kind protector of the Arts. Almost alone amongst the countries of Europe she has proved herself incapable of producing that small band of wealthy people, who are open to ideas, ahead of the musical-comedy and academics of their age, and prepared to spend a few hundred pounds a year less on petrol or social pyrotechnics, and buy pictures.'[1]

In the very next sentence, as if to acknowledge the fact that he had over-stated the case, Lewis swiftly qualified his argument. 'Even in England a few such people exist', he conceded, before pointing out that 'it is all the more credit to them, being so lonely'.[2] In Lewis's view, these oases of enlightened patronage were scattered in a desert of Anglo-Saxon philistinism. While the English had long proved themselves eager to expend substantial sums on the art of the past, especially from Italy, they shied away from a vigorous involvement with experimentalism. Some collectors were willing to pay remarkably inflated prices for paintings displayed at the Royal Academy summer exhibitions, but the avant-garde had no hope of benefiting from such extravagance. London dealers were not prepared to buy their work in any quantity, let alone offer them exclusive contracts in return for guaranteed annual incomes. Since there were no counterparts to Parisian dealers like Vollard or Kahnweiler, they counted themselves fortunate if even a modest sale was made. Most of the time, they were obliged to rely on the generosity of friends, fellow artists and the occasional purchase from collectors who could scarcely afford to pay them a reasonable price.

Lewis himself was cheered when his first exhibited painting, the now lost *Port de Mer*, was bought from the second Camden Town Group show in 1911 by

his erstwhile mentor Augustus John. This 'largish canvas' of 'two sprawling figures of Normandy fishermen, in mustard yellows and browns'[3] was regarded at the time as 'the British advance-post' and 'extraordinarily simplified'[4] in form. It must therefore have been far more extreme than John's own work, but he made the purchase and Lewis afterwards described it as 'a circumstance which gave me unusual pleasure'.[5] Such acquisitions meant a great deal to the artists concerned, even if small amounts of money were involved. They demonstrated, in a straightforward and yet encouraging way, that the work was not automatically doomed to remain unsold and invisible at the back of the studio.

All the same, more imaginative and ambitious forms of patronage managed to give artists the opportunity to push their work in directions they might otherwise have never been able to explore. Such a feat was performed by Ezra Pound soon after he met Henri Gaudier-Brzeska in 1913. At the time Pound's dissatisfaction with the progress of Imagism, his experimental poetry movement, had persuaded him to turn towards advanced English artists instead. He was already involved with the ideas of Lewis and Epstein, and their work predisposed him to admire Gaudier's sculpture at the Allied Artists' annual exhibition. He saw the artist himself nearby, following at a distance 'like a well-made young wolf or some soft-moving, bright-eyed wild thing'.[6] Gaudier eventually introduced himself to the appreciative poet, and they soon became friends. But Pound realized that Gaudier was desperately in need of financial support. Although his own resources were very limited, he decided to spend some of the £40 given to him by W. B. Yeats from a prize awarded by *Poetry* magazine on two small carvings. Gaudier's delight with the transaction was reciprocated by Pound, who informed William Carlos Williams in December 1913 that he had 'just bought two statuettes from *the* coming sculptor, Gaudier-Brzeska. I like him very much. He is the only person with whom I can really be "Altaforte" … We are getting our little gang after five years of waiting.'[7]

Realizing that Gaudier responded to the stimulus of congenial commissions, Pound followed up these preliminary purchases by asking him to carve a marble reliquary of a recumbent female nude for presentation to Wilfred Scawen Blunt. Gaudier and his new supporter shared a growing belief in the need to revitalize British sculpture by moving away from traditional sources of inspiration in Renaissance and Classical precedents. They looked instead at the so-called 'primitive' carvings from Africa and Oceania, and Pound declared in a combative essay on 'The New Sculpture' that 'we turn back, we artists, to the powers of the air, to the djinns who were our allies aforetime, to the spirits of our ancestors'.[8] Gaudier agreed, arguing that 'the modern sculptor' has 'no relation to classic Greek' but 'is continuing the tradition of the barbaric peoples of the earth (for

whom we have sympathy and admiration)'.[9]

By the time he made that proclamation in March 1914, Gaudier was already at work on a monumental carving of Pound's head. It would turn out to be the most arresting manifestation of his respect for Oceanic art, and his sitter insisted on purchasing the large block of marble himself. Sessions took place in Gaudier's ramshackle studio underneath a railway bridge, but he took extreme liberties with the features of a sitter obliged to perch 'on a shilling wooden chair in a not over-heated studio with the railroad trains rushing overhead'.[10] Taking his cue above all from the colossal Easter Island figure called *Hoa-Haka-Nana-Ia* in the British Museum, Gaudier warned Pound that the carving 'will ... not ... look ... like you. It will be the expression of certain emotions which I get from your character.'[11] Virility is the carving's most obvious attribute, and observers were quick to remark on its phallic identity.[12] But it is also an immensely calm and rigorous sculpture, paring Pound's facial features into a sequence of severely simplified elements. Austere to an almost glacial extent, and yet alive with the latent energy which its subject possessed in such abundance, the carving ended up presenting Pound as a seer. It suggests that Gaudier wanted above all to stress the critical acumen which had prompted him, not only to champion the most inventive forces in British sculpture, but offer them his unusually stimulating patronage as well.

Apart from encouraging Gaudier to produce one of his grandest and most impressive carvings, Pound could do little to alleviate the sculptor's chronic impecuniosity. Only a collector of means was in a position to make substantial purchases, and Gaudier enlisted before anyone began to collect his work on a significant scale. Soon afterwards, though, Pound succeeded in drawing him to the attention of perhaps the most remarkable and discerning avant-garde collector of the age, the New York lawyer John Quinn.[13] Having amassed a prodigious array of innovative European and American art, most notably from purchases at the Armory Show in 1913, Quinn needed no persuading about the central importance of Post-Impressionism, Fauvism and Cubism. He had, however, made few British acquisitions beyond buying heavily from his friend and sporadic adviser Augustus John. Realizing that a new generation was now at work in London, Quinn felt obliged to respond when Pound wrote a headlong assault in 1915 on the failure of patrons to save Epstein from near-bankruptcy. 'One looks out upon American collectors buying autograph MSS. of William Morris, faked Rembrandts and faked Van-dykes', wrote the splenetic poet. 'One looks out on a plutocracy and upon the remains of an aristocracy who ought to know by this time that keeping up the arts means keeping up living artists; that no age can be a great age which does not find its own genius.'[14]

Quinn, who had been an admirer of Pound's poetry since they met in America five years before, regarded this outburst as a personal challenge. 'If there is a "liver" collector of vital contemporary art in this country, for a man of moderate means,' he wrote to Pound, 'I should like to meet him.'[15] Having been alerted to Gaudier's achievement by Pound's philippic, Quinn went on to ask how he could acquire the Frenchman's work. Sensing a possible source of major patronage for many of his artist friends, Pound lost no time in promising to send Quinn photographs of Gaudier's work. Moreover, he appended a passionate letter about the most positive role a patron can play in nurturing emergent artists. 'My whole drive is that if a patron buys from an artist who needs money (needs money to buy tools, time and food), the patron then makes himself equal to the artist: he is building art into the world; he creates', Pound declared. 'A great age of painting, a renaissance in the arts, comes when there are a few patrons who back their own flair and who buy from unrecognized men. In every artist's life there is, if he be poor, and they mostly are, a period when £10 is a fortune and when £100 means a year's leisure to work or to travel ... If you can hammer this into a few more collectors you will bring on another cinquecento.'[16]

Pound's argument was so forcefully expressed that Quinn found it impossible to resist, and the appalling news of Gaudier's death on the Western Front moved him to ask Pound whether he would buy on his behalf as many prime examples of Gaudier's work as possible. 'Poor brave fellow', Quinn wrote with emotion, observing that 'there is only the memory now of a brave gifted man. What I can do I will do.'[17] With outstanding generosity, he further undertook to finance the considerable costs involved in mounting a Vorticist exhibition in New York. Pound was delighted, and helped to ensure Quinn's continuing commitment to the project by lauding Lewis's new drawings in an unabashed panegyric which likened them to 'every kind of geyser from jism bursting up white as ivory, to hate or a storm at sea. Spermatozoon, enough to repopulate the island with active and vigorous animals. Wit, satire, tragedy.'[18] Pound's indomitable capacity to convey enthusiasm for his friends' work knew no bounds, his urgency fired by the knowledge that he was now interceding on behalf of men who had, for the most part, departed for the killing fields of France. He managed to sustain Quinn's interest until a consignment of work was at last shipped to New York and, in January 1917, placed on view as the Vorticists' first and only American exhibition at the Penguin Club on East 15th Street.[19]

By this time Quinn had spent around £500 on work in the exhibition, as well as acquiring a group of outstanding recent carvings by Epstein, including the marble *Mother and Child* later donated to the Museum of Modern Art in New York.[20] All the show's expenses were covered by the lawyer, who subsequently

bought a further range of work from the Vorticists' exhibition in order to round off his representation of their achievements. With understandable satisfaction, Pound was able to report that Quinn 'has about cleared up the whole show … It runs to 375 pounds, which ought to contradict the premature reports of the death of "le mouvement" '.[21] The value of such support, especially to artists embroiled in trench warfare and unable to produce any more work of their own, can scarcely be exaggerated. Quinn's commitment alleviated an otherwise depressing period for the avant-garde, and even the acerbic Lewis felt grateful enough to thank his American patron in surprisingly effusive terms. 'Let me say how much I appreciate your action in buying my drawings, and all the kindness and interest you have shown in my work and my friends', he wrote to Quinn. 'I see what it means for a man to be angel enough to find himself invariably on the side of the angels. Your support is at once a privilege and of incalculable use to the few artists with whom I am associated here. Let me speak for them.'[22]

Lewis's gratitude must have been intensified by his awareness that no one in London was prepared to match Quinn's informed and unstinting commitment. The only British collector who approached him in enthusiasm for the European avant-garde was Michael Sadler, Vice Chancellor of Leeds University since 1911 and a man fired by a zeal for the beneficent effects of education. He delighted in sharing the pleasure derived from his purchases, frequently hanging many of the English pictures in his collection in the halls, corridors and canteens of the university buildings. Work by Vanessa Bell, Roger Fry, Duncan Grant and Bernard Meninsky became a familiar part of the students' lives, and they also had the opportunity to view the French paintings in Sadler's own quarters. While studying at Leeds School of Art, Henry Moore was profoundly excited by what he later described as the 'tremendous experience'[23] of visiting Sadler's collection and seeing, for the first time, original examples of Post-Impressionist work. Among the Cézannes and van Goghs were canvases as outstanding as Gauguin's *The Vision after the Sermon*, but the most audacious fruits of Sadler's buying were paintings by a younger and far more controversial artist.

Unlike the Post-Impressionist pictures, which he had acquired since the artists' deaths, Sadler's group of Kandinskys arose from direct and convivial contact with the painter himself. After his son had purchased some woodcuts by Kandinsky for a few shillings, they visited him in Murnau. The day went well, with several paintings and drawings bought from the studio, and when they missed the last train back to Munich the artist lent them some nightshirts for their stay in a local hotel. At one stage a *Blaue Reiter* exhibition was planned in London as well as an extended visit to England by Kandinsky.[24] But the advent of war disrupted everything, driving him into exile and coinciding with the waning

[27]

of Sadler's enthusiasm for the latest work of an artist who was now entering his most abstract phase. In December 1913 a Christmas gift was sent to Leeds from Murnau, and Sadler remembered that Kandinsky had here 'expressed himself in free, non-representational design. The pattern of the composition had broken free from orthodox decoration, as vers libre departed from conventional metre. The design, strong in structure and balance, suggested hurtling masses in impending collision. The dominant colours were vermilion, black, purple, sulphur yellow, and blood red.'[25]

Despite his immense admiration for Kandinsky's work, Sadler appears to have concluded that the pursuit of abstraction was leading its adherents 'perilously near to reducing art to the diagrammatic'.[26] Hence, no doubt, his decision to stop well short of purchasing any English work motivated by a desire to explore the possibilities of non-representational form. It is surely significant that his acquisitions of Edward Wadsworth's work came from the *Black Country* series of 1919, when the artist was already retreating from the structural abstraction of his Vorticist work. Although drawings like *Ladle Slag, Old Hill 2* are still informed by the rigour which Wadsworth developed during the Vorticist period, they revert to the convention of a representational view. So do Grant's Cézannesque painting of *Farm Buildings* and Bell's *Triple Alliance*, a sprightly mixed-media collage produced at the height of her interest in abstraction and yet still adhering to a recognizable account of the still life assembled on a table-top. Sadler's marked preference for work of this kind led him to purchase one of Ben Nicholson's earliest surviving paintings, where a clearly identifiable striped jug is placed before a sheet of fabric in open homage to similar compositions by the artist's father.[27]

Sadler's unwillingness to accept the desirability and even, perhaps, the viability of abstraction was shared by Edward Marsh, another prominent collector of contemporary English art. Even though he served as Winston Churchill's Private Secretary for over twenty years,[28] Marsh had a far more open-minded view of modern painting than his master. The Damascan moment in his appreciation of twentieth-century art occurred at the Carfax Gallery in December 1911, where the Camden Town Group temporarily included among its ranks the young Duncan Grant. His lyrical painting of *Parrot Tulips*[29] enchanted Marsh so much that he bought it at once, thereby bringing to an end his earlier concentration on work by Crome, Cozens, Girtin and Wilson. Once he had made this dramatic leap, and met artists like Mark Gertler, the Nash brothers and Stanley Spencer who were still studying at the Slade, Marsh concluded that 'buying Old Masters in shops began to seem a sheeplike, soulless conventionalism. How much more exciting to back what might be roughly called one's own

judgement … to go to the studios and the little galleries, and purchase, wet from the brush, the possible masterpieces of the possible Masters of the future. Besides, to buy an old picture did nobody any good except the dealer; whereas to buy a new one gave pleasure, encouragement and help to a man of talent, perhaps of genius. I still don't see how anyone can hesitate between the two.'[30]

Like Sadler, Marsh bought art for love rather than profit and left the bulk of his collection to public galleries through the Contemporary Art Society. He also found himself competing with Sadler over Spencer's early masterpiece *Apple Gatherers*. After the painting had been sent to Leeds in 1913 and Sadler made an offer of £50, Marsh visited the Spencer family home in Cookham and offered £55 to conclude a deal on the spot. In so far as it was a painting which clearly disclosed Spencer's fascination with Gauguin and Post-Impressionism, *Apple Gatherers* proclaimed the most experimental side of his art. But Marsh, who bought a more orthodox self-portrait and landscape on the same visit, could

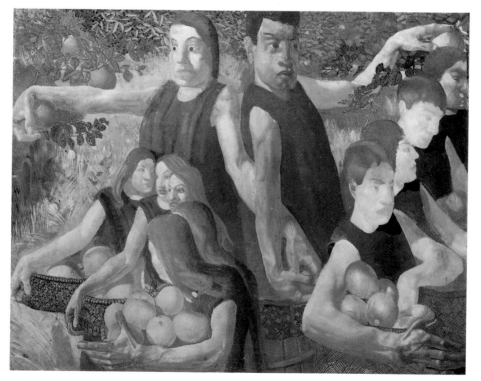

Stanley Spencer 1891–1959
Apple Gatherers 1912–13
oil on canvas, 71.4 × 92.4 cm
presented by Sir Edward Marsh, 1946
The Tate Gallery, London

never be described as a devotee of the avant-garde. He was, after all, a friend of Rupert Brooke and the partisan editor of five volumes of *Georgian Poetry* – a publication implicitly opposed to the literary revolution promulgated by Pound. So Marsh could hardly be expected to acquire work by the most extreme of Spencer's contemporaries. He only bought David Bomberg's paintings well after his youthful involvement with machine-age abstraction had come to an end.[31] As for Lewis, Marsh decided on their very first meeting that they were incompatible. 'Another new light whom I met today is Wyndham Lewis (I am going to the Picture Ball, if you please, as a futurist picture designed by him!)', he told a friend in November 1913. 'He is very magnificent to look at, but I don't think he liked me, and I suspected him of pose, so we shan't make friends. Hoping to strike a chord, I told him I had spent the day with Stanley Spencer, and he said, "I don't know him, is he a painter?" Which *must* have been put on.'[32]

After that uneasy encounter Marsh left Lewis's work alone until 1923, when he acquired a relatively traditional drawing of a *Woman's Head*.[33] For the artists he really admired, however, his generosity was legendary. After meeting Gertler in the summer of 1913 and buying his melancholy yet stoical early painting of a *Jewish Family* for £35, Marsh visited him regularly and offered, in November 1914, to guarantee Gertler £10 a month for the duration of the war. In return he only asked for the right of first refusal on new paintings, and at one stage in 1915 Marsh let Gertler stay with him while the artist searched for a new studio in Hampstead. He even sent his neurasthenic protégé to Churchill's doctor, and the painter's subsequent letter shows how much Marsh's help meant to him. 'I really cannot express my thanks to you for your extraordinary goodness', Gertler wrote. 'I must tell you I feel that what you are doing for me is *far* more valuable to me than anybody else has ever done. The only thing is that you shall have to have patience with my work.'[34]

Gertler must have suspected that Marsh would be unable to stomach the increasingly strident and mechanistic tenor of his painting, which culminated the following year in the rasping, hallucinatory horror of *The Merry-Go-Round*. But while Marsh could never have become reconciled to such a disturbing image, his reply to Gertler was warmly reassuring. 'Sometimes I take to your things at once and am fascinated and enchanted, as I was by the "Daffodils",' Marsh wrote, 'but that can't happen every time, and the only thing I ask is that you should not be hurt or depressed if I don't take to everything as immediately as I did to that! … All I want is that you should go ahead on your own lines, and that I should be able to help you and make things easier for you.'[35]

It was an admirably sympathetic attitude to adopt, and Gertler compared Marsh's approach favourably with Sadler's when he travelled to Leeds in order to

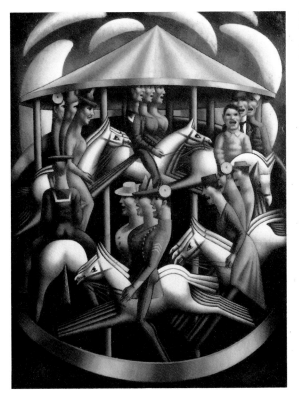

Mark Gertler 1891–1939
The Merry-Go-Round 1916
oil on canvas, 189.2 × 142.2 cm
The Tate Gallery, London

begin work on a commissioned portrait of the university's Vice Chancellor. 'I simply can't do it', he wrote to Marsh in August 1915, explaining that 'it is just a terrible pain to me to do. Since I have been here, I have appreciated even more your help to me … you just let me paint what I paint.'[36] In this respect, Marsh was surely instrumental in helping Gertler achieve the ultimate ferocity of *The Merry-Go-Round*, even though he made no attempt to acquire this baleful *tour de force* himself.

A similar claim can be made about his relationship with Paul Nash, who in December 1914 was given a key to Marsh's flat to enable him to stay in London more frequently. Astonished by the profusion of pictures displayed in these confined premises, Nash realized with admiration that 'the question of wall space, which perplexes so many people who live in comparatively small rooms and want to buy pictures, did not arise here. Every available inch of wall space was occupied. Pictures began in the hall, ran up the stairs, along the passage, and were only pulled up short by the bathroom … E.M. was the first real collector I had met and I remember thinking to myself, if all collectors collect in this way we shall all live happy ever afterwards.'[37]

Just as Marsh respected Gertler's absolute freedom to explore any path he chose, so he encouraged Nash to transform his own art. Marsh's first acquisition

was a visionary 1914 watercolour of *Elms*,[38] and he exercised a preference throughout Nash's life for his quieter, English-inspired landscapes.[39] But when he saw the work Nash had executed in response to his initial experience of the Ypres Salient in 1917, he showed no hesitation in helping John Buchan obtain an Official War Artist's commission for his young friend. The powerful work Nash went on to produce after his second visit to the Western Front was uncompromising in its vehement indignation, and found no place in Marsh's collection. But he would have recognized its passionate authenticity, and felt gratified that he had helped Nash produce images as fiercely eloquent as the ironic *We Are Making a New World*.

The limits so clearly detectable in the private collections formed by Marsh and Sadler reappear when the public acquisitions of the Contemporary Art Society are examined. Although the committee's Post-Impressionist leanings were declared in the decision to accept Fry's gift of Gauguin's unfinished *Tahitians*, its members showed a notable reluctance to support any of the artists associated with more recent avant-garde movements like Fauvism, Cubism and Futurism. Despite an attempt in December 1912 to set aside £50 towards the purchase of a Matisse,[40] nothing came of the initiative. As Fry discovered to his intense chagrin, the CAS resisted the whole notion of acquiring foreign art.[41] It also avoided buying the work of British artists who strayed too far beyond the bounds of Post-Impressionism. Paintings by Bell and Grant were purchased as early as 1912, backed no doubt by the partisan presence on the committee of both Fry and Clive Bell. But aside from Gertler, whose *Fruit Sorters* was acquired during Lady Ottoline Morrell's time as buyer in 1915, most of his outstanding Slade contemporaries remained overlooked.

Purchases of Lewis's work were restricted to his pre-Vorticist period, when Clive Bell appears to have acquired 'a big canvas' of *The Laughing Woman* which later disappeared.[42] Perhaps it perished in the calamitous flooding of the Tate Gallery's cellars where another supposed Lewis purchase, an early 'over-lifesize gouache of three smiling women',[43] was destroyed. Both these images may well have sprung from a characteristically subversive bid, on Lewis's part, to challenge the stylistic conventions on which Augustus John's celebrated painting of *The Smiling Woman* was based.[44] The first canvas to be bought by the CAS, it had generated considerable controversy at the time. But Lewis, who was then struggling to escape from the influence of John and establish his own identity, defined his *Laughing Woman* in a form-language overtly indebted to the early phase of Cubism. She was the harbinger of a revolutionary spirit in British art, and her laughter might have been laced by an implicit scorn for John's adherence to a more traditional way of seeing.

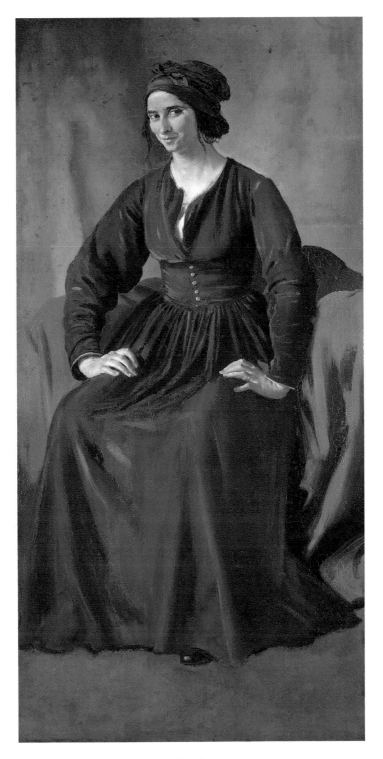

Augustus John 1878–1961
The Smiling Woman c.1908
oil on canvas, 195.6 × 96.5 cm
purchased by the Selection
Committee, 1910
presented to the Tate Gallery,
London, 1917

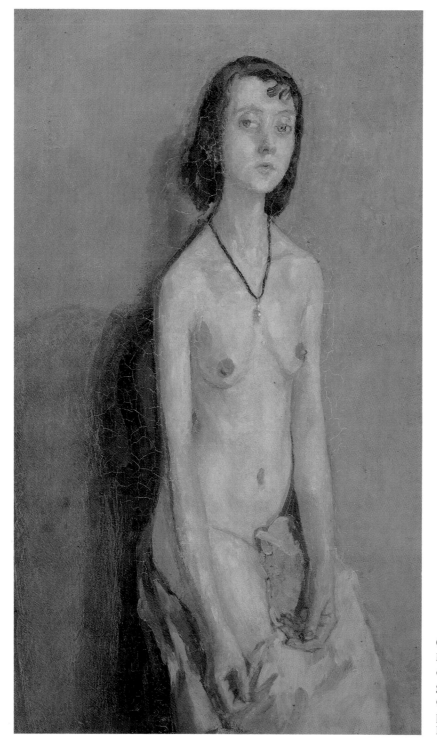

Gwen John 1876–1939
Nude Girl 1909–10
oil on canvas, 44.5 × 27.9 cm
given by a member of the
committee, 1911
presented to the Tate Gallery,
London, 1917

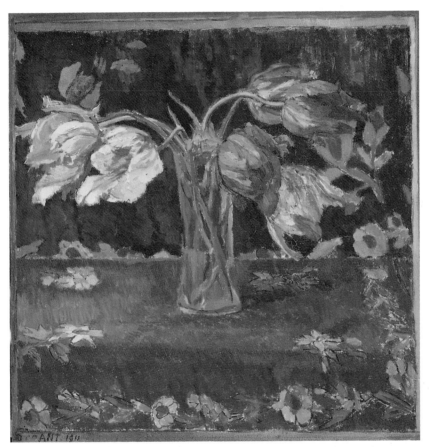

Duncan Grant 1885–1978
Tulips 1911
oil on canvas, 52 × 49 cm
Sir Edward Marsh Bequest, 1953
presented to Southampton City Art
Gallery, 1954

Stanley Spencer 1891–1959
Early Self Portrait 1912–13
Red chalk on paper, 23.5 × 21.6 cm
Sir Edward Marsh Bequest, 1953
presented to the Williamson Art Gallery, Birkenhead, 1954

Charles Ginner 1878–1952
Sunlit Square, Victoria Station 1913
oil on canvas, 76 × 88 cm
purchased by Sir Cyril Kendall-Butler, 1916
presented to Bootle Art Gallery, 1924

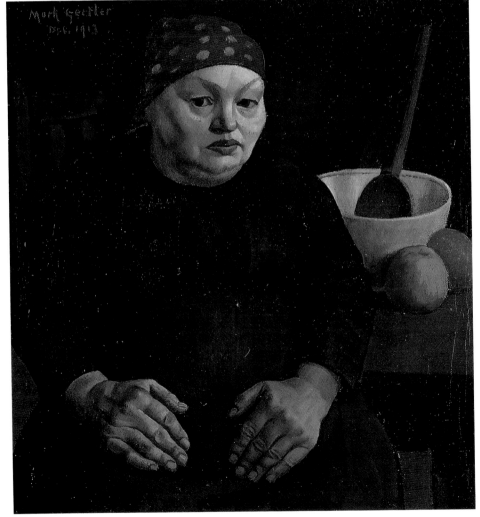

Mark Gertler 1891–1939
Portrait of the Artist's Mother 1913
oil on canvas, 44 × 41 cm
Sir Edward Marsh Bequest, 1953
presented to Glynn Vivian Art
Gallery, Swansea, 1954

OPPOSITE
Walter Richard Sickert 1860–1942
*Ennui c.*1914
oil on canvas, 152.4 × 112.4 cm
Special purchase, 1914
presented to the Tate Gallery,
London, 1924

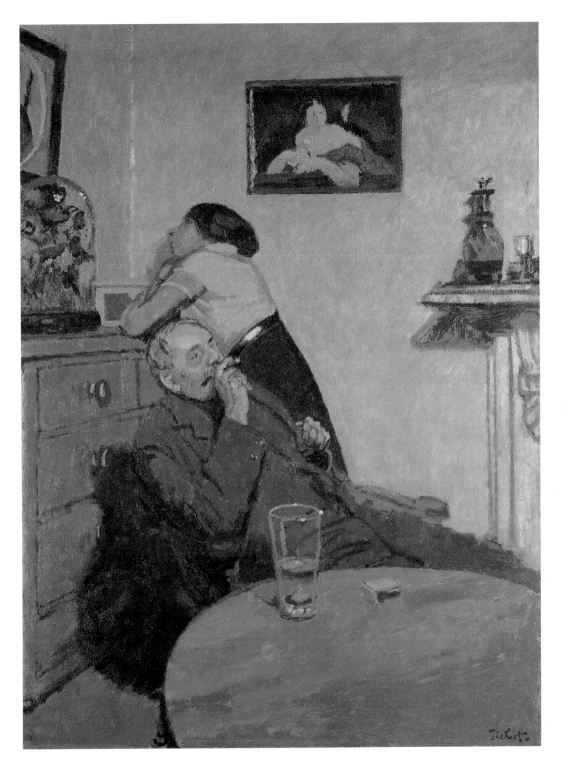

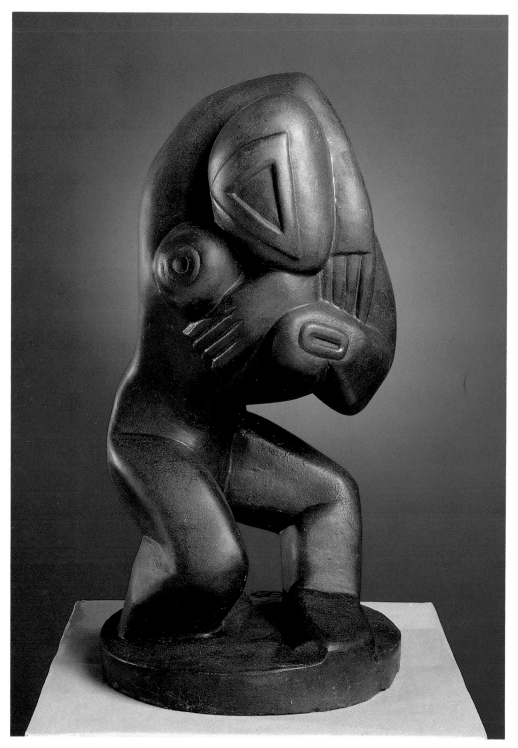

Henri Gaudier-Brzeska 1891–1915
Red Stone Dancer c.1913
red Mansfield stone, polished and
waxed, 43.2 × 22.9 × 22.9 cm
presented by C. Frank Stoop,
through the CAS, to the Tate Gallery,
London, 1930

[40]

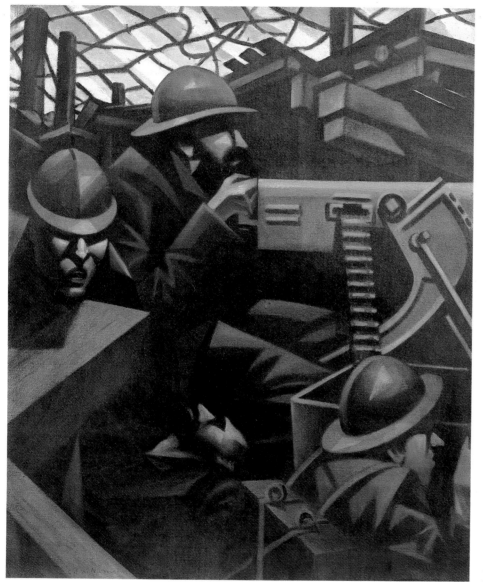

C. R. W. Nevinson 1889–1946
La Mitrailleuse 1915
oil on canvas, 61 × 50.8 cm
presented by an anonymous
American lady, 1916
presented to the Tate Gallery,
London, 1917

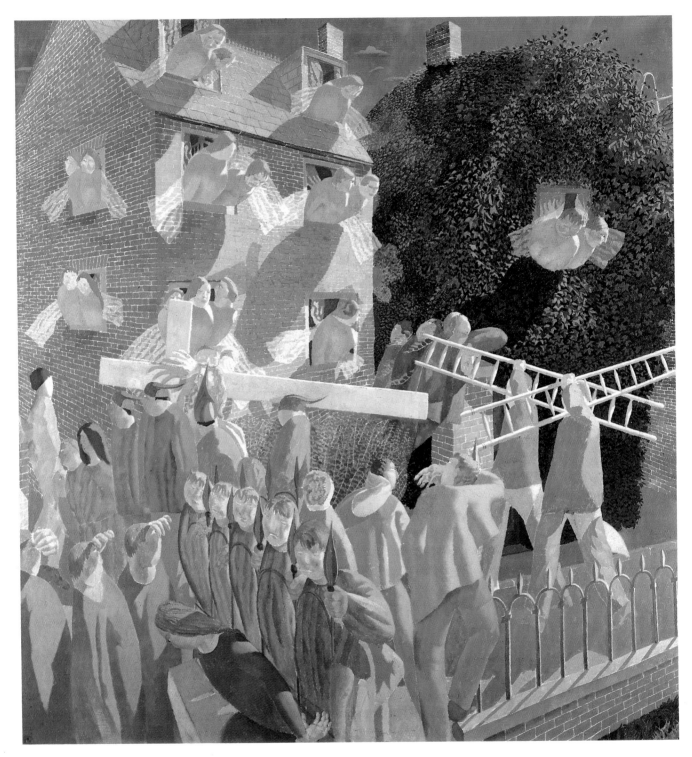

OPPOSITE
Stanley Spencer 1891–1959
Christ carrying the Cross 1920
oil on canvas, 153 × 142.9 cm
purchased by Muirhead Bone, 1921
presented to the Tate Gallery,
London, 1925

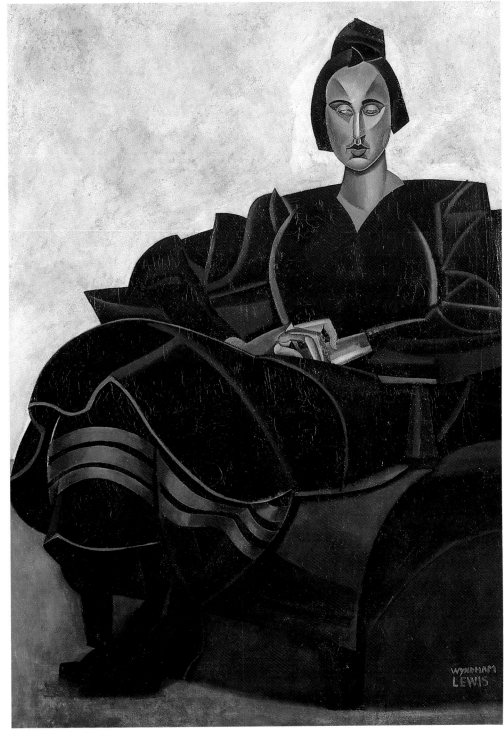

Percy Wyndham Lewis 1882–1957
*Praxitella c.*1921
oil on canvas, 142.2 × 101.6 cm
presented by Edward Wadsworth,
through the CAS,
to Leeds City Art Gallery, 1944

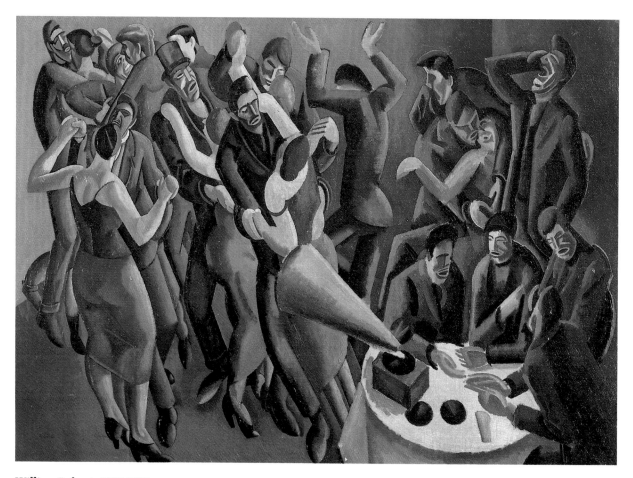

William Roberts 1895–1980
The Dance Club 1923
oil on canvas, 76.2 × 106.6 cm
given by Muirhead Bone, and others, 1925
presented to Leeds City Art Gallery, 1927

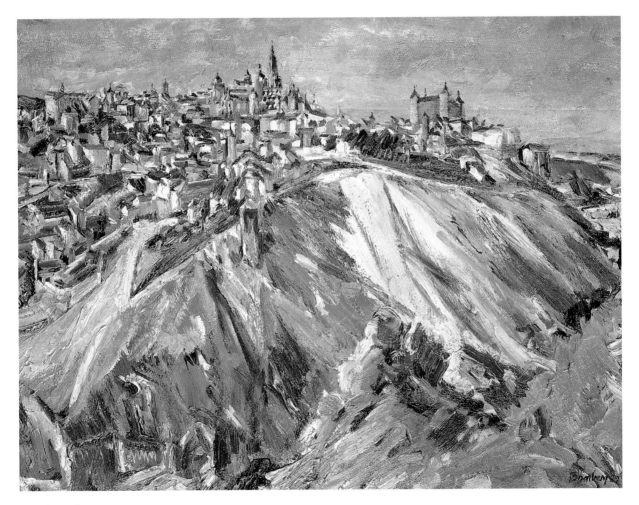

David Bomberg 1890–1957
Toledo and River Tajo 1929
oil on canvas, 58.4 × 76.2 cm
purchased by Lord Howard de Walden, 1931
presented to Oldham Art Gallery, 1943

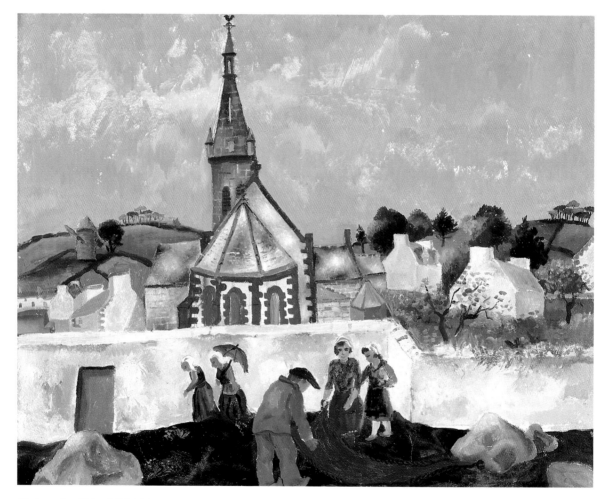

Christopher Wood 1901–30
Church at Tréboul 1930
oil on board, 73 × 91.4 cm
presented by the artist's parents, through the CAS,
to the Tate Gallery, London, 1930

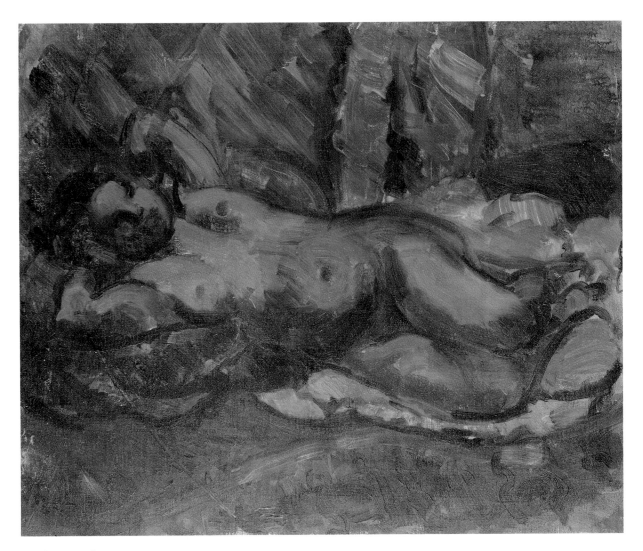

Matthew Smith 1879–1959
Reclining Nude n.d.
oil on canvas, 65.4 × 79.3 cm
purchased by Roger Fry, 1924
presented to Cartwright Hall, Bradford, 1931

Edward Burra 1905–76
Storm in the Jungle 1931
watercolour, 55.4 × 67.9 cm
purchased by Sir John Rothenstein, 1964
presented to Nottingham Castle Museum, 1968

The CAS refused to follow Lewis and his allies after they embarked on the Vorticist crusade. In 1915, when their first group exhibition was staged at the Doré Galleries in London, the CAS contented itself with acquiring Lucien Pissarro's latter-day Impressionism and a work by Henry Tonks, who had made his vehement abhorrence of Cubism abundantly clear to the students he taught at the Slade. Within its limits, though, the CAS's purchases still offered a relatively open-minded corrective to the narrow academic precepts upheld by the administrators of the Chantrey Bequest. While they persisted in filling the Tate collection with expensive paintings from successive summer exhibitions at Burlington House, the CAS bought a major Sickert[45] and characteristic examples of work by his Camden Town colleagues Ginner and Gore.[46]

The most courageous CAS acquisition of the period was, however, a painting by an artist whose earlier work had been shunned by the committee. Before he served in the war as an ambulance driver for the Red Cross, C. R. W. Nevinson had been a fervent disciple of the Futurist cause. First-hand experience of suffering soon forced him to question his adherence to Marinetti's belligerent glorification of battle. Invalided home from France, he began to feel angry about the atmosphere in England. 'Back I went to London, to see life still unshaken, with bands playing, drums banging, the New Armies marching and the papers telling us nothing at all',[47] he remembered later. The pictures Nevinson began producing in 1915 had the temerity to provide a markedly less glamorous vision of life at the Front. He must have known that these canvases flouted the expectations voiced by jingoistic journalists, who called for images offering a complacent and morale-raising view of the war. Although his work attracted a great deal of attention in the press, Nevinson soon became aware of hostility both from diehard patriots and Bloomsbury critics who considered the war a 'vulgar' subject for a modern artist. 'To me the soldier was going to be dominated by the machine', he explained later. 'Nobody thinks otherwise today, but because I was the first man to express this feeling on canvas I was treated as though I had committed a crime.'[48]

One of the strongest of these controversial canvases is *La Mitrailleuse*. Taking as his subject the weapon which caused so much devastation during all those doomed infantry advances, Nevinson presents a terse, grim-visaged view of a French machine-gun post in the trenches. The gunner has become almost as dehumanized as the machine he wields. Hemmed in by barbed-wire fences and sharp-edged wooden blocks, he crouches over the controls and waits for the enemy to appear. But there is no suggestion of impending triumph here. One of his companions lies prone and blanched on the ground already, while another yells desperately for assistance or fresh supplies of ammunition. The gruesome

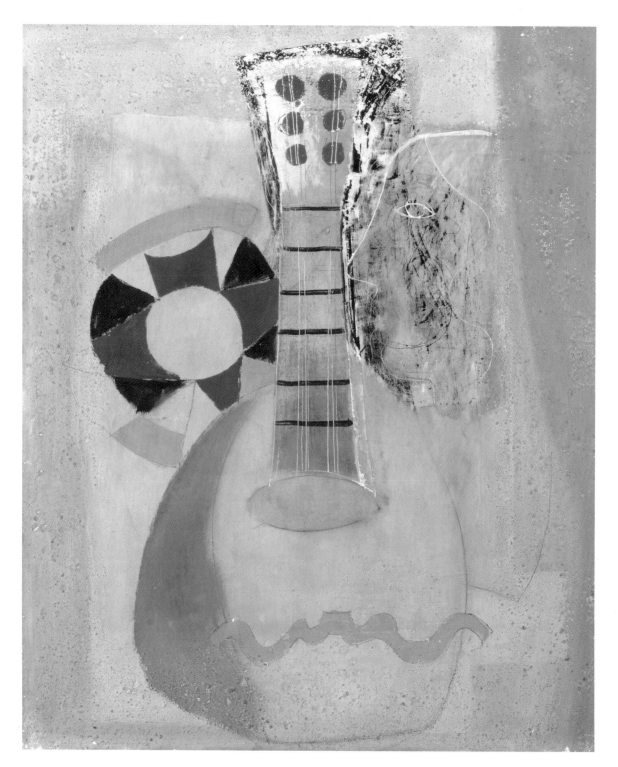

Ben Nicholson 1894–1982
Still Life with Guitar 1933
oil on board, 76.2 × 63.3 cm
purchased by Sir Philip Hendy, 1951
presented to Leeds City Art Gallery, 1951

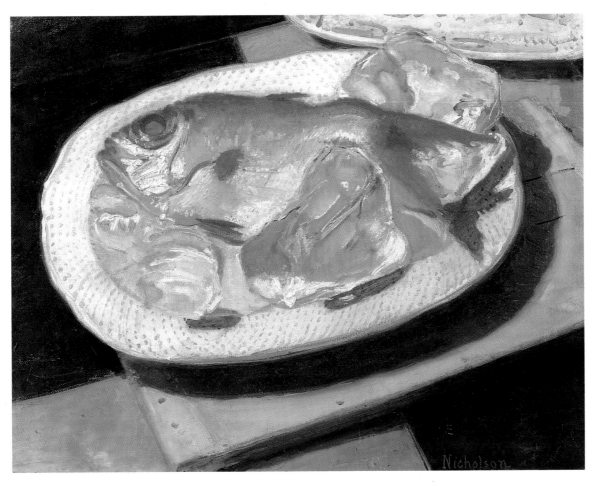

William Nicholson 1872–1949
The Sun Fish 1935
oil on canvas, 50.8 × 63.5 cm
purchased by Campbell Dodgson or Maynard Keynes, 1936
presented to the Council for the Encouragement of Music and
the Arts (later the Arts Council of Great Britain), 1942

meaning Nevinson wanted to convey now seemed more important than loyalty to the Futurist movement, and Lewis took satisfaction in describing soon afterwards how Nevinson had written 'to the compact Milanese volcano that he no longer shares, that he REPUDIATES, all his (Marinetti's) utterances on the subject of War ... Marinetti's solitary English disciple has discovered that War is not Magnifique, or that Marinetti's Guerre is not la Guerre. Tant mieux.'[49]

The CAS must have agreed with him, for it acquired La Mitrailleuse in 1916 and presented it to the Tate Gallery the following year. Since the war was still at its height, the meaning which Nevinson invested in his canvas bore with painful directness on the lives of those viewing it at Millbank. Indeed, the battle had become so murderous by then that few people in Britain remained personally unaffected by its carnage. Nevinson's insistence two years earlier on emphasizing the conflict's harrowing aspects had been amply justified by the subsequent course of a struggle more tragic than anyone could have predicted, and the CAS's brave, timely acquisition enabled a great many of the Tate's visitors to realize how prescient an avant-garde artist could be about the condition of the modern world.

Notes

1. Wyndham Lewis, 'Constantinople Our Star', Blast, 2 (1915), p.11
2. Ibid.
3. Wyndham Lewis, Rude Assignment. A Narrative of My Career Up-to-Date (London, 1950), p.121
4. Frank Rutter, The Sunday Times, 3 December 1911
5. Wyndham Lewis, Rude Assignment, op. cit., p.121
6. Ezra Pound, Gaudier-Brzeska. A Memoir (London, 1916), p.45
7. Ezra Pound to William Carlos Williams, 19 December 1913, in D. D. Paige (ed.), The Letters of Ezra Pound, 1907–1941 (London, 1951), p.65
8. Ezra Pound, 'The New Sculpture', The Egoist, 16 February 1914
9. Henri Gaudier-Brzeska to the editor, The Egoist, 16 March 1914
10. Ezra Pound, Gaudier-Brzeska. A Memoir, op. cit., p.50
11. Ibid.
12. Epstein, for example, recalled that 'Pound had asked him to make it virile and this Gaudier was endeavouring to do, explaining to me the general biological significance' Jacob Epstein, Let There Be Sculpture (London, 1942 edn), p.59.
13. For a detailed assessment of Quinn's activities as a collector, see Judith Zilczer, "The Noble Buyer": John Quinn, Patron of the Avant-Garde (Washington, 1978)
14. Ezra Pound, The New Age, 21 January 1915
15. John Quinn to Ezra Pound, 25 February 1915, quoted by B. L. Reid, The Man from New York. John Quinn and His Friends (Oxford, 1968), p.198
16. Ezra Pound to John Quinn, 8 March 1915, ibid., pp.199–200
17. John Quinn to Ezra Pound, 27 July 1915, ibid., p.204
18. Ezra Pound to John Quinn, 10 March 1916, ibid., p.252
19. The catalogue was entitled Exhibition of the Vorticists at the Penguin
20. The gift was made by A. Conger Goodyear in 1938
21. Ezra Pound to Helen Saunders, c. November 1917, Cornell University Library
22. Wyndham Lewis to John Quinn, 24 January 1917, in W. K. Rose (ed.), The Letters of Wyndham Lewis (London, 1963), p.86
23. Henry Moore, quoted by W. T. Oliver, 'Sadler as Art Collector', Michael Sadler (Leeds, University Gallery, 1989), p.17

24. See Michael Sadleir, *Michael Ernest Sadler: a Memoir* (London, 1949), p.239

25. Michael Sadler, 'Premonitions of the War in Modern Art', unpublished press release of a lecture delivered in Leeds, 26 October 1915, Brotherton Library, Leeds University

26. Michael Sadler, unpublished report on his lecture 'What is the Secret of Art?', dated 27 July 1921, Brotherton Library

27. The paintings by Bell, Grant and Nicholson are all now owned by the University of Leeds Collection

28. With two short breaks, Marsh worked for Churchill between 1905 and 1928

29. *Parrot Tulips* (now titled *Tulips*) is now in Southampton City Art Gallery, presented through the CAS.

30. Edward Marsh, quoted in *An Honest Patron. A Tribute to Edward Marsh* (Liverpool, Bluecoat Gallery, 1976), p.46

31. The two Bombergs bought by Marsh were *Street in Jerusalem* (1924) and *Ronda, Spain* (1933), both now owned by Professor E. Boyland

32. Edward Marsh to Elliott Seabrooke, November 1913, quoted by Christopher Hassall, *Edward Marsh: Patron of the Arts* (London, 1959), p.258

33. *Woman's Head* is now in the British Museum

34. Mark Gertler to Edward Marsh, May 1915, quoted in *An Honest Patron*, op. cit., p.28

35. Edward Marsh to Mark Gertler, 26 May 1915, ibid., p.30

36. Mark Gertler to Edward Marsh, August 1915, ibid.

37. Paul Nash, *Outline. An Autobiography and other writings* (London, 1949), p.137

38. *Elms* is now in the Walker Art Gallery, Liverpool

39. Marsh's final Nash acquisition was *November Moon* (1942), now in the Fitzwilliam Museum, Cambridge

40. See Judith Bumpus, 'The Contemporary Art Society – A Significant Contribution' in *The Contemporary Art Society 1910–1985* (London, 1986), p.7

41. In 1917 the CAS Minutes recorded that 'Mr. Fry suggested that the Society might be able to use its influence in promoting the proposed purchase of a picture by Gauguin for the Gallery of Modern Continental Art [in the Tate] but no definite proposal for any action was made' (13 November 1917). Fry broadened his attack two years later, proposing 'a grant towards the formation of a fund for the purchase of pictures by foreign artists' (Minutes, 15 July 1919). His suggestion was not pursued, however, and Fry's subsequent frustration led to his threatened resignation from the CAS in the 1920s (see Bumpus, ibid., pp.7–9).

42. See Walter Michel, *Wyndham Lewis Paintings and Drawings* (London, 1971) pp.333–4, for details of the painting, which was included in the CAS exhibition of April 1913.

43. See ibid., p.349

44. For a fuller discussion of Lewis's attitude towards John's *The Smiling Woman*, see Richard Cork, *Vorticism and Abstract Art in the First Machine Age. Volume 1: Origins and Development* (London, 1975), pp.18–20

45. Sickert's *Ennui*, now in the Tate Gallery, was purchased by the CAS in 1914

46. Ginner's *Sunlit Square, Victoria Station* and Gore's *Houghton Place* were both bought in 1916

47. C. R. W. Nevinson, *Paint and Prejudice* (London, 1937), p.104

48. Ibid., p.107

49. Wyndham Lewis, 'The Six Hundred, Verestchagin and Uccello', *Blast*, 2, op. cit., p.25

Ivon Hitchens 1893–1979
Winter Stage 1936
oil on canvas, 59.1 × 155.6 cm
purchased by Maynard Keynes or Sir
Edward Marsh, 1937
presented to the Tate Gallery,
London, 1938

Graham Sutherland 1903–80
Welsh Landscape with Roads 1936
oil on canvas, 61 × 91.4 cm
purchased by Jasper Ridley, 1938
presented to the Tate Gallery,
London, 1946

Tristram Hillier 1905–83
La Route des Alpes 1937
tempera on canvas, 59.7 × 80.6 cm
purchased by John Rothenstein,
1943
presented to the Tate Gallery,
London, 1944

The Contemporary Art Society: Development and recognition 1920–1940 Frances Spalding

For the Contemporary Art Society the interwar years were a period of consolidation and development. Though its first report after the return of peace did not appear until 1924, it published one annually thereafter until 1930 when it was agreed that biennial reports, handsomely printed by the Curwen Press, would be more economical and would detract less from the money available for acquisitions. The Society's income still came solely from donations and subscriptions which remained at one guinea per annum for individual members throughout this period. As membership steadily increased, its limited funds rose but remained well below those at the disposal of the Chantrey Bequest. In 1931 the CAS was incorporated and officially registered as a charity, subscriptions thereafter being paid through the National Council of Social Service and claimable against income tax. Throughout this period the purpose of the CAS gradually became better known. More provincial art galleries joined the scheme which continued to enrich public collections up and down the country.

In the aftermath of war contemporary art suffered a failure of nerve. The huge loss of life suffered during the war, combined with the social and economic reorganization that followed its cessation, created a climate in which artistic experimentation seemed out of place. Instead there was a widespread return to traditional methods of representation and familiar subjects, notably landscape. Even Wyndham Lewis's attempt to reformulate an avant-garde seemed half-hearted: under the anonymous title 'Group X' it held one exhibition in March 1920 after which its identity ceased.

It must therefore have been difficult during the early 1920s to ascertain with any confidence where significant developments in contemporary art were taking place. CAS purchases were at first minimal and cautious. Six works were acquired in 1920, five in 1921, and eight in 1922. Two of these were by the portraitist, John Wheatley, others were by artists nowadays forgotten – C. S. Chester, Neville A. Lewis, E. H. Hubbard and Miss L. Pickard – and the rest were by painters whose reputations had been established before the war: Mark Gertler, William Roberts, W. R. Sickert, Wyndham Lewis, Gilbert and Stanley Spencer. But however limited and disappointing the purchases made during these three years may seem, the

CAS did acquire, in Stanley Spencer's *Christ carrying the Cross*, an undoubted masterpiece.

One person on the committee at this time was the civil servant, Edward Marsh, whose interests as a collector (described in the preceding essay) would appear to have had a determining influence on CAS purchases. Though Roger Fry also remained a member of the committee, the hectic pace of his busy life, as well as his frequent absence on lengthy painting trips abroad, meant that he was probably a less significant figure than Edward Marsh who enlivened his speeches, when he eventually became Chairman, with apposite and erudite quotations. He not only made substantial gifts of works of art to the CAS at regular intervals during his lifetime (also donating the profits from his memoir of Rupert Brooke), but he further demonstrated his commitment to the CAS in his will: in 1954 almost every public gallery in Britain benefited from the Sir Edward Marsh Bequest.

At this time it was the Society's practice to divide its annual income into two halves: one of which was to be spent by the committee as a whole; the other, by a single member of the committee who was appointed buyer for twelve months. Purchases were either to be retained by the CAS and lent from time to time to exhibitions or they were presented outright to some public gallery. At this stage the committee retained its right to sell after a certain number of years pictures which it did not wish to keep and to use the money thereby obtained to buy new work.

In an attempt to increase the Society's base an exhibition was held in 1923 at Grosvenor House, home of the Duke and Duchess of Westminster, of principal paintings and sculpture acquired by the CAS. 'The Exhibition was largely attended,' the report for 1919 to 1924 noted, 'and favourably noticed by the Press; but response to the appeal which was made for fresh funds was disappointingly small.' Throughout this period as a whole the Society continued to arrange visits and social events to raise interest in its activities. The most notable of these was a visit, by gracious consent of HM The King, to Buckingham Palace in 1934 to see pictures in the Royal Collection.

Shortage of money, however, did not prevent the CAS from setting up in 1919 a fund for the specific purpose of acquiring modern prints and drawings, both British and foreign. No rules were officially laid down as to how this fund should be managed, but in the 1919 to 1924 report it was stated that the drawings and prints would remain in the possession of the Society for a period and subsequently enter the Prints and Drawings Collection in the British Museum. It is easy to see how this understanding was arrived at for the committee member placed in charge of this fund was Campbell Dodgson, the great print expert,

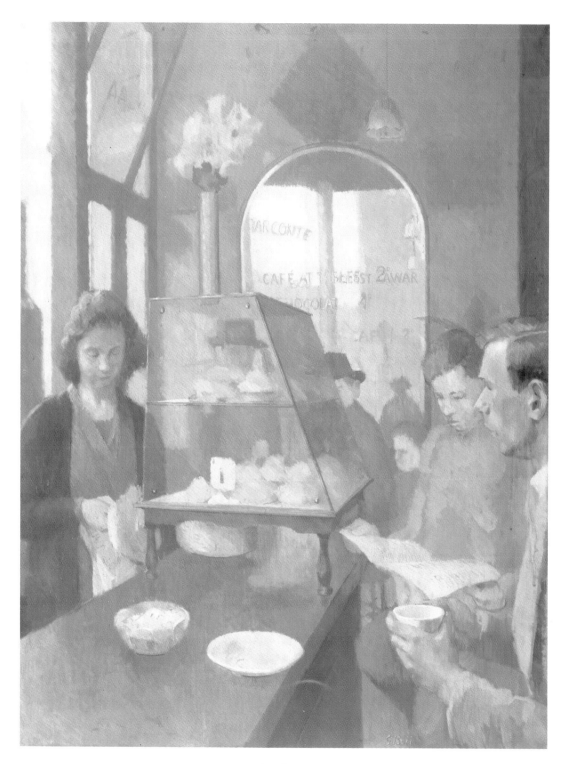

OPPOSITE
Graham Bell 1910–43
The Café 1937–8
oil on canvas, 121.9 × 91.7 cm
Special purchase, with contributions from Sir Kenneth Clark,
John Hugh Smith and Gerald Kelly, 1938
presented to Manchester City Art Gallery, 1943

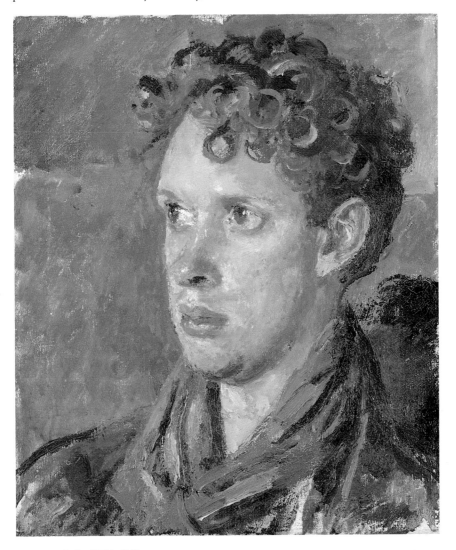

Augustus John 1878–1961
Portrait of Dylan Thomas 1937–8
oil on canvas, 41.4 × 35 cm
purchased by Miss Thelma Cazelet, 1941
presented to the National Museum of Wales, Cardiff, 1942

collector and the British Museum's Keeper of Prints and Drawings. In 1932, when Campbell Dodgson was approaching retirement, the policy of the CAS with regard to its control of the Print Fund had to be reconsidered and advice was sought from two other British Museum officials, Laurence Binyon and A. M. Hind. After a discussion at a committee meeting held 23 June 1932, H. S. Ede wrote the following minute: 'It was agreed that the rule existing, namely that the Keeper of Prints and Drawings should "ex officio" administer the Fund, should be retained.' But in the minute book Ede flagged this remark with a sign and wrote in the margin: 'Note: no such rule ever existed. H. S. Ede.' The committee was, however, aware that its relationship with the British Museum was constricting and reserved the right to amend its constitution if this seemed desirable. 'At the same time,' the minutes continue, with that combination of cautiousness, goodwill and inertia which frequently characterizes committee decisions, 'the advantages of co-operation with the Museum were fully appreciated and furthermore due weight was attached to the consideration which was advanced in the Keeper's memorandum, that a change of rule at this particular moment might be open to misinterpretation.' In 1934 however, when Campbell Dodgson gave up his control of the Prints and Drawings Fund, the CAS, at a meeting held 22 November 1934, nominated as his successor A. M. Hind, 'on the understanding that this nomination was personal to Mr Hind and not in his official capacity as Keeper of Prints and Drawings at the British Museum.' The minutes also state that in future twenty-five per cent of the Prints and Drawings acquired through the CAS should be disposed of to provincial galleries.

It was the Prints and Drawings Fund which responded first to the desire of the CAS in the early 1920s to act upon its original brief to include work by artists of foreign nationality. Campbell Dodgson acquired works on paper by Marie Laurencin, Redon, Degas, Forain, Segonzac, Vlaminck and others, while the paintings and sculpture added to the collection remained purely British. In 1925, however, a separate Foreign Fund was set up to remedy the situation. The 1925 report announced that £1,000 had been provided anonymously for this fund, with the proviso that the committee must match this amount. At the time that the report was published some £700 had already been raised. The Foreign Fund continued in existence throughout this period and was used to acquire works by Picasso, Matisse, Rouault and other eminent European artists. But foreign acquisitions remained a small part of the CAS's overall policy, the main thrust of which continued to be directed towards improving the representation in public art galleries of contemporary British artists.

Purchasing during the 1920s remained uneven, attention being given to artists whose reputations have not sustained the test of time as well as to those

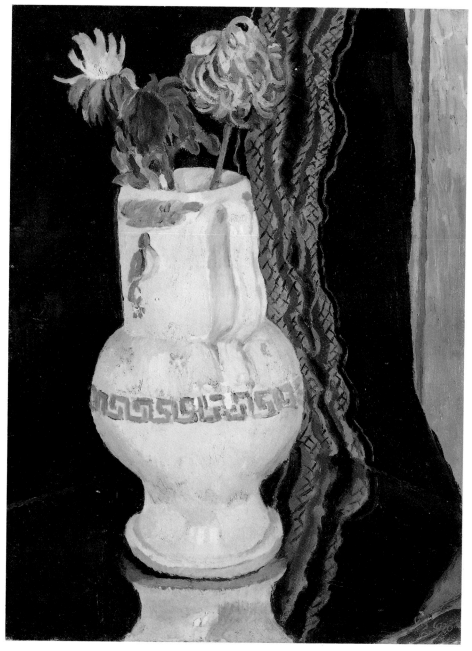

Vanessa Bell 1879–1961
Chrysanthemums 1920
oil on canvas, 61 × 45.7 cm
purchased by Sir Edward Marsh, 1923
presented to the Tate Gallery, London, 1924

Henry Moore 1898–1986
Recumbent Figure 1938
Green Hornton Stone, 88.9 × 132.7 × 73.7 cm
purchased by Sir Kenneth Clark, 1939
presented to the Tate Gallery, London, 1939

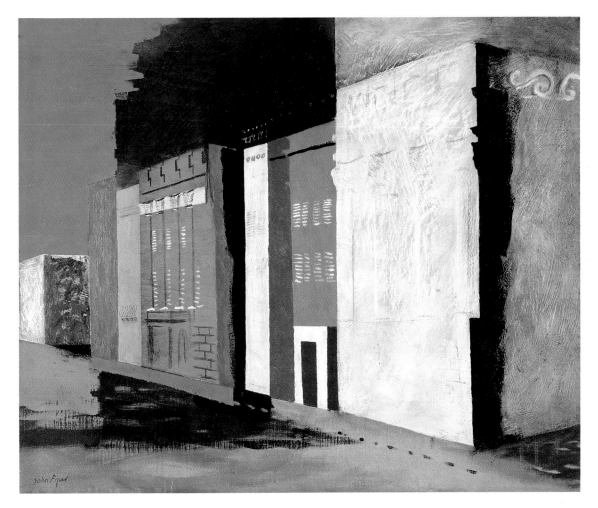

John Piper b.1903
Dead Resort, Kemptown 1939
oil on canvas over panel, 45.7 × 55.8 cm
purchased by Sir Kenneth Clark, 1939
presented to Leeds City Art Gallery, 1941

who have achieved renown. Certain artists seem to have been particularly favoured by the CAS, among them Vanessa Bell, Frank Dobson, Duncan Grant, Cedric Morris, Paul Nash, Stanley Spencer and William Roberts. Owing to the willingness of the committee to accept gifts, it was possible for an individual collector, such as Sydney Schiff, effectively to stamp his taste on the acquisitions for any one year. In 1925, for example, when only eight purchases were made, there were eighteen gifts, thirteen of which came from Edward Marsh. Nevertheless, arguably the most significant acquisition of that year was a purchase – T. W. Monnington's *Decoration*, based on the theme of Adam and Eve in the Garden of Eden and which is over nine feet in length and now in the Tate Gallery's collection. In terms of size alone, it is very obviously a work intended for public display rather than private collection.

Though the executive committee included artists (Muirhead Bone, Roger Fry) and administrators (Campbell Dodgson, A. M. Daniel), it was at any one time predominantly composed of collectors, St John Hutchinson, the Earl of Sandwich, Samuel Courtauld, Montague Shearman, Sir Michael Sadler and Lord Ivor Spencer-Churchill among them. Though the CAS benefited time and again from gifts from these collectors, most brought to their work for the scheme a taste which, through the practice of collecting, was already well entrenched. Even Roger Fry, who before World War I had been closely associated with avant-garde ideas, was no longer *au courant* with innovative practices. Towards the end of the 1920s he himself began painting in styles that preceded Post-Impressionism and his presence on the committee did not prevent it purchasing works in 1927 by Christopher Hall, Campbell Grey, Ernest Gage and Evan Walters, none of whom, by today's standards, would appear to have contributed significantly to the development of contemporary art at that time. Purchases in 1928 again suggest that the committee preferred to ignore developments that were taking place within the 7 and 5 Society, in favour of the well-tried Camden Town artists, Walter Bayes and Derwent Lees, and acceptable minor figures within the London Group and London Artists' Association such as R. V. Pitchforth and Elliott Seabrooke. It did, however, risk its arm with acquisitions by Mary McCrossan, Winston McQuoid, Geoffrey Nelson and M. K. Rolls, artists on whom information is nowadays difficult to obtain. Bizarre and unpredictable though some of these purchases were, they did include a delightfully idiosyncratic pastiche on Hogarth – Rodney Burn's *The Red Lion Inn*.

The motley nature of CAS purchases during the 1920s continued to be disguised by the excellence of many gifts. In 1928 Lord Ivor Spencer-Churchill, Edward Marsh and the CAS President, Lord Howard de Walden gave generously, adding, among other items, three Sickerts to this year's acquisitions. The

collector Helen Sutherland also offered works of art to the CAS. The committee accepted six of these, including two by Ivon Hitchens and a Winifred Nicholson; but among the works offered by this notable patron and friend of artists which the CAS refused were two oils by Ben Nicholson. The committee, it seems, had its doubts about Nicholson's *faux-naïf* approach which belied his aesthetic sophistication. Certainly at least one artist felt disgruntled with the Society's achievement: in 1931 the former Vorticist, Edward Wadsworth, withdrew his subscription which he had been paying at the generous rate of ten guineas a year. The reason that he gave for doing so was that the Society was neither a *Contemporary* nor an *Art* Society. The committee deputed the Honorary Secretary to write to Mr Wadsworth in order to discover which artists' work he considered suitable for purchase. There is no record of any reply.

If the committee was unadventurous it did not lack informed taste. In 1928 it extended its brief with the setting up of the Pottery and Crafts Fund which was administered by Ernest Marsh. Margaret Bulley (Mrs Armitage) asked it for support in connection with the collection of modern crafts that she was making, with the stated intention that, when complete, the collection would be handed over to the Victoria and Albert Museum. The fall-off in private buying, owing to the repercussions that followed the Wall Street crash, sharpened the need for just the kind of patronage and encouragement for artists and craftsmen that the CAS provided.

The Society also acted as intermediary between donors and institutions, smoothing the mechanics of formal acceptance. In this way a part of Sir Michael Sadler's collection entered the Cooper Art Gallery at Barnsley. Similarly in 1929 Belfast Art Gallery asked the CAS to administer a fund left by a Mr Lloyd Patterson. It enabled the CAS to acquire more than twenty works for Belfast. The following year, Lord Ivor Spencer-Churchill became the CAS buyer. He was succeeded, in 1931, by Lord Howard de Walden. It was this year that the CAS acquired its first Ben Nicholson, an oil of St Ives. The report for 1930–31 persuasively argued: 'A moment's reflection on the vast sums spent annually on the purchase of the Art of the past should convince us as to the expediency of buying effectively before the verdict of successive generations places on certain modern works a value beyond the reach of the ordinary purse.'

By the early 1930s the CAS could look with satisfaction on its achievement to date. It was awarded public recognition by Frank Rutter in an article in *The Sunday Times* in which he compared the CAS purchases with those of the Chantrey Bequest. He pointed out that the CAS had spent less than a tenth of the amount spent by the Chantrey Fund and that the pictures purchased by the CAS were of considerably higher aesthetic value. The committee sent Rutter a letter of thanks.

It continued to arrange special visits each year to houses and collections not usually open to the public. Membership of the CAS also brought with it free access to certain galleries and museums which charged for entrance. The committee kept a watch on the Society's membership and was pleased to note in 1933 that, though fifty-six had dropped out in the last two years, ninety-nine had come in and subscriptions from provincial art galleries were increasing.

In 1934 the death of Roger Fry meant that the CAS lost one of its founder-members. Maynard Keynes was elected in Fry's place to the sub-committee in charge of the Foreign Fund. The following year money from this was used to acquire three watercolours by Rouault from the Roger Fry estate. It was also decided that in 1935, in recognition of the CAS's achievement over the last twenty-five years, a Silver Jubilee exhibition of its most important purchases should be held at the Tate. It ran for a month, in July, and was formally opened by the actress, Marie Tempest.

The *raison d'être* of the purchasing policy remained unchanged. Its implementation must necessarily have been affected by various factors, including availability of certain items and not others. Almost certainly discussion must have taken place as to which artists were worthy of consideration, but no such debate is recorded in the minutes of the committee's meetings. It seems to have been accepted that the individual purchaser for each year should proceed without restraint of any kind on his personal taste, interests and, in some cases, friendship with artists. The list of works bought in 1934 by St John Hutchinson and in 1933 by Mr C. L. Stocks included names that continue to be regarded as significant, among them Vanessa Bell, Eric Gill, Paul Nash, John Skeaping, Matthew Smith and Ethel Walker. But no interest had yet been shown in the work of the young sculptors, Barbara Hepworth and Henry Moore, though four works by Ben Nicholson had been bought by 1934. Nicholson considered one of these a poor example of his work and in 1936 he offered the committee one of three oils in exchange for the work which he wished to destroy. The committee agreed to his request and exchanged *Two Jugs* for an oil entitled *Composition*. Overall the CAS in the mid 1930s failed to give sufficient attention to abstract and constructive developments and to Surrealism. It is perhaps also regrettable that in 1936 it rejected the gift offered by Captain Bruce Ingram – Carel Weight's *Black Rain and Fire and Hail*.

H. S. Ede, the Assistant Secretary, was authorized to arrange gifts of CAS works to provincial art galleries. Though directors of these galleries were invited to indicate which works they would like to add to their collections, there is evidence of a wish on their behalf to be more involved with the scheme as a whole. At a meeting of the Museums Association in 1937 a Mr Silvester of the

Russell-Cotes Art Gallery and Museum, Bournemouth, proposed that one or more directors of the provincial art galleries should represent the interests of these directors on the executive committee of the CAS and should be in a position to criticize purchases made by the Society. Such a suggestion proved too radical for the Association to countenance and the Chairman of the Congress, with the approval of other delegates, ruled out this resolution as being unsuitable for discussion. Instead members of the Museums Association expressed satisfaction with the present working of the CAS and passed an agreement that they did not feel it necessary to take any initiative in proposing representation on the committee. It was, however, added that if the executive committee of the CAS wanted to invite co-operation, then the Association would be ready to choose a representative but saw no reason, in the present circumstances, to make this suggestion themselves.

The next person to be co-opted on to the committee was Kenneth Clark, whose presence ensured that certain members of the Euston Road School found representation in CAS purchases, and the scheme continued in the hands of the great and the good. Maynard Keynes and Edward Marsh were the buyers for 1937, Marsh taking over when Keynes, owing to illness, was unable to continue, and purchases remained worthy but unrepresentative of the avant-garde. The committee, however, was far from complacent. When in 1936, following the death of Sir Cyril Kendall-Butler, who had served the committee in various roles since its debut, Edward Marsh took over as Chairman, he expressed concern about membership. Though this had risen from 450 to 514 in the last year, it was still, Marsh argued, far too small, and a drive began to enlist local support for the CAS in provincial towns with galleries, with particular concentration on York, Newcastle and Bristol. The relationship between the metropolitan-based CAS and provincial art galleries remained a point of contention. In 1938 the Director of Leeds City Art Gallery expressed dissatisfaction with the scheme, arguing that his particular gallery was not getting works of quality in return for its subscription. He was promptly given two works for which he had applied: Gilbert Spencer's *The Shepherds Amazed* and T. W. Monnington's *Figures in Landscape*. This same year Keynes drew the committee's attention to a letter in *The Times*, signed by various artists, which urged public art galleries to acquire works by Wyndham Lewis. In reply A. M. Hind pointed out that a drawing by Lewis had already been acquired by the CAS, but a certain antagonism to Lewis can be felt behind the minute that 'the Committee agreed ... the buyer for the year should remain quite unbiased' in his choice of new acquisitions.

As well as the benefit that the CAS brought to national and provincial collections, it also fertilized exhibitions and generously lent works to town halls,

schools and galleries. It also boosted the representation of British artists abroad, notably at the exhibition of modern British art held at the Empire Exhibition in Johannesburg in 1936. It attended not only to large-scale exhibitions, such as the circulating collection of some 100 prints and drawings which went on tour in 1934, but also agreed to individual loans such as the decision to lend the YWCA club in Dagenham a design for an altar piece by Eric Gill for a period of three years.

By the outbreak of war, the CAS found itself in a strong position. Several art dealers, sympathetic to its cause, had encouraged their clients to join the Society and had helped add seventy new members over the past few months. In addition Messrs Agnew, who had recently moved into the field of contemporary art, had donated a percentage on their sales from a recent exhibition.

The CAS was in addition proud to see examples of its purchases included in the National Gallery exhibition, 'British Painting since Whistler', mounted by Sir Kenneth Clark. Furthermore one of its key purchases during 1939 had been Henry Moore's *Recumbent Figure* which the CAS donated to the Tate Gallery. It should, however, be noted that the first public art gallery to attempt to acquire a Moore was Wakefield. When asked by this gallery in February 1939 for assistance with its purchase of an elmwood *Reclining Figure*, the CAS havered, eventually deciding 'that they were not in a position to assist in this matter'; and though Moore reduced the asking price of the work from 300 guineas to £150, it was not until 1942, and against certain local opposition, that Wakefield was able to own this carving. Nevertheless the acquisition of both Moores represents a landmark in the history of twentieth-century British art, one that affirmed the strength of indigenous contemporary art and the continuing intransigence of the British imagination.

British arts and patrons 1940–1960
Joseph Darracott

Setting the scene

'Penrhyn cannot have been a cheerful setting for ordinary life, and with its dark walls covered by large, dark canvasses it was exceptionally dismal.' So wrote Kenneth Clark in his autobiography about his first attempt to find a wartime haven in a country house for the National Gallery's pictures. His second shot was an 'abandoned slate quarry in the midst of a hill called the Manod, not far from the hellish town of Blaenau Ffestiniog in North Wales'. He was under pressure to send the pictures abroad, but the Prime Minister wrote an instruction in red ink: 'Bury them in the bowels of the earth, but not a picture shall leave this island, W.S.C.'[1]

The problem solved, Clark was in a good position to be useful to contemporary British art. His major achievement was the successful government patronage of the War Artists' Advisory Committee; he was the prime mover and Chairman from first to last. This government body commissioned more than 5,500 works, including major paintings by older artists like Paul Nash and Stanley Spencer, and significant bodies of work by such artists as Edward Ardizzone, Edward Bawden, Anthony Gross and Eric Ravilious, besides three artists personally associated with Clark as a patron, Henry Moore, John Piper and Graham Sutherland.[2]

Another scheme of commissions for artists was called 'Recording Britain'. This was a topographical survey, carried out between 1941 and 1943, financed by the Pilgrim Trust, which ran to 1549 works. It was complementary to another and more comprehensive record of buildings, the National Buildings Record; to give an idea of their respective sizes, in the summer of 1942 'Recording Britain' had 727 drawings, while the National Buildings Record had 130,000 photographs. 'Recording Britain' was the subject of an exhibition in 1990, accompanied by an admirable book.[3]

The war artists' scheme and 'Recording Britain' had more than one feature in common; both employed a good many illustrators, but also, and significantly, both had been devised partly as a way of ensuring some employment for artists in wartime. Clark was later frank about the war artists: 'My aim, which of course I did not disclose, was simply to keep artists at work on any pretext, and, as far as possible, to prevent them from being killed.'[4] He was less outspoken during the

war itself, as the success of his committee depended on delicate manoeuvring in Whitehall; even the committee's continued existence was at times uncertain.

Large-scale schemes of patronage for artists have been rare in twentieth-century Britain, and these two schemes were perhaps only made practical by the circumstances of war. Certainly, in the depression during the 1930s there had been no British initiative like the WPA commissions for American artists, a scheme which Clark knew and admired. There had, however, been extensive commissioning of British artists in World War I, which proved a helpful precedent in the next. Clark's committee even included one of the official World War I artists, Sir Muirhead Bone; he was just the man to be part of 'a committee that would be more or less acceptable to conservatives and yet be in sympathy with the left'; particularly as Clark judged that in Royal Academy circles at that time he himself was considered 'a dangerous revolutionary'.[5]

The art politics of the 1940s could usefully be given a closer look, perhaps especially focusing on the prestige of official art. The Contemporary Art Society was mainly in opposition to the Royal Academy; works by Academicians were rarely purchased by the Society, whose buyers tended to look for new talents which could be developed and encouraged. The Academy's star exhibitors could, in the Society's view, look after themselves. There was thus a natural alignment in taste between purchases for the Society and commissions given by the war artists' committee. A characteristic overlap was the purchase for the Society by Maynard Keynes of four shelter-scene drawings by Henry Moore.

The war years were not easy for artists; however, a welcome new patron appeared, the Council for the Encouragement of Music and the Arts, which was given money by the Pilgrim Trust for buying pictures to form a travelling exhibition. The Council began with seventy-five oil paintings and watercolours. A different scale of purchasing began after the Arts Council absorbed the collection in 1946, though between 1949 and 1959 the primary aim of buying was for exhibitions. Isobel Johnstone, writing the foreword to the collection's catalogue in 1979, had some regrets:

To some degree it was hoped that the extensive exposure of their work would directly benefit artists by creating a new buying public. So far this has not happened to any great extent, and the Arts Council is one of the few sources of patronage for many artists. For this reason it has always been important that the Council should qualify its aim of acquiring a collection of the best contemporary art by two considerations – the need to buy as wide a range of work as possible and to make sure that funds are fairly spread between established artists and the younger or less well known.[6]

The Contemporary Art Society never had so wide a mandate, and rather little cause for regret. The Society's membership grew steadily through the 1940s

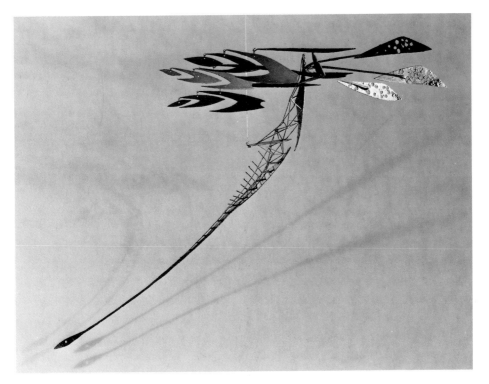

Lynn Chadwick b.1914
Dragonfly 1951
Iron mobile, length 294.6 cm
purchased by the committee, 1951
presented to the Tate Gallery, London, 1951

and 1950s, showing that goodwill for the arts had been created, even if not a whole 'new buying public'. Whereas in 1946 there were around 300 members of the Society, in 1953 there were 1750, much of the credit for this being given by the committee to Denis Mathews, the Assistant Secretary. The relatively small number of purchases made by the Society's buyers persisted in being discriminating, indeed often decisively important. The roll call of artists whose works first entered the Tate Gallery through the Society continued to swell; Paul Klee, André Masson and Edouard Pignon from abroad, and Lynn Chadwick, Cecil Collins, Lawrence Gowing, Frances Hodgkins and Peter Lanyon turned up between 1940 and 1960.

The postwar world saw some new patronage for artists, one important moment being the Festival of Britain in 1951. A new art institution had by then

appeared in London, the Institute of Contemporary Arts, with a potential for focusing left-wing and avant-garde interests. The rebuilding of Coventry Cathedral was a notable occasion for artistic patronage, but sadly rare in its alliance of architect with artists. But for most artists the basis of their professional practice was work for private collectors. This was also the most familiar arena for the Society, and where we shall look next.

Some collectors

It was a time of sensitive and sometimes altruistic collecting. Edward le Bas, in writing about a group of works from his own collection shown in 'Seventeen Collectors' at the Tate Gallery in 1952, gives a typical sense of a personal commitment to collecting:

I have bought these pictures because I enjoy looking at them. Living in the day-to-day world, where one is constantly threatened by petty or temporal values, it is no small pleasure to have on the walls these various and complete visual worlds of shape and colour, each one made by the artist with thoughtful and emotional values that are both innocent and, I hope, enduring.[7]

The le Bas collection at that time was strongest on British painting, with a quota of works by Walter Sickert, Harold Gilman, Charles Ginner and Paul Nash, but it also included works by Matisse, Léger and Klee. A main emphasis on British art, with a deferential nod to European masters, was not unlike the contribution the CAS was making to the country's galleries.

Le Bas had a quiet but consistent taste, so it is no surprise to learn that when he was buying for the Society in 1947 his choices included works by William Coldstream, John Minton, Claude Rogers and Carel Weight. He had an inclination to representative, or, as Edward Marsh preferred to say, interpretative art. Le Bas should perhaps be correctly placed in the Marsh succession, a worthy and respectable position.

Sir Edward Marsh (although everyone called him Eddie, not Edward) had almost stopped buying after his retirement from the civil service in 1937, so that his collection reflected the taste of an earlier period. During his lifetime he had presented more than a hundred works to the Society, and at his death in 1953 he bequeathed it his collection.

The Marsh collection demonstrates a taste with twin roots in his own generous character and his early enthusiasm for artists like the Spencers and the Nashes. He always had an eye for a picture, but at the beginning he had bought old masters. His conversion came 'about three years before the first war' when he changed direction (see p.28).[8]

He was rightly appreciated: 'The friendship of Eddie Marsh', wrote Winston Churchill, 'is a memory which I place high among my treasures … He was not only an admirable Civil Servant, on whose judgement, loyalty and competence I could always count, but he was a master of literature and scholarship, a deeply instructed champion of the arts, and a man for whom the esteem of his friends could not fail to be combined with their deepest affection.' His successor as Chairman of the Society was Raymond Mortimer who commented on his upholding the Society's method of buying: 'Eddie was sometimes visibly shaken when he saw the pictures chosen by the buyer of the year, but he was convinced like all the other members of the Committee, that the buyer's freedom must remain absolute.'[9]

Another major collector, a decade older than Marsh, was Sir Michael Sadler (see pp.27–8), who had generously given works during his lifetime to a number of galleries. After his death, in 1943, the Society bought a Rouault landscape and a Modigliani drawing from his collection; they enriched the Tate Gallery.

Another substantial benefactor to galleries, but in this case directly through the CAS was Sir Kenneth Clark, fortunate to have inherited money but wise and generous enough to use it well. His paintings shown in 'Seventeen Collectors' included great names – Rodin, Renoir and Matisse, as well as British art with which he was in sympathy. As a personal collector, Clark experimented: 'my collection … represents a compromise between taste and opportunity … it takes time to know what one really wants, and the process of discovering leaves one with a number of trial pieces.'[10] Clark made two generous benefactions to the Society, presenting fifty-six works in 1947, and giving a further twelve works in 1951.

Clark's choices were in a well-established tradition; just as the Marsh collection had a firm basis in his early enthusiasms, so Clark's purchases started with the young artists with whom he had found sympathy in the thirties, such as Moore, Piper, or Sutherland, and then reached out to other interests like the painters of the Euston Road School, or individual talents like that of Carel Weight and of younger painters like John Craxton. Clark's gifts to the Society ensured that galleries throughout the country had good work by some of the best young artists, reinforcing the representation already established by distributing war artists' pictures.

Other collectors of the period used their more limited resources for buying particular favourites. Howard Bliss, for example, lent pictures to 'Seventeen Collectors' commenting wryly that the selection 'does less than justice to painters such as Hitchens and Scott, for whose pictures I have special fondness'.[11] As a buyer for the Society in 1955 his taste extended from more

established painters like Louis Le Brocquy, Victor Pasmore and Lawrence Gowing to younger talents like Donald Hamilton Fraser, John Christoforou and David Tindle.

Raymond Mortimer felt that the times had conspired against him as a collector: 'The glorification of the human spirit and body which I find so enriching in Italian art has, alas, almost disappeared from contemporary painting. Despite my longing for beautiful nudes and idealised myths, I find myself buying pictures of instruments for frying fish.'[12] But this wistfulness did not prevent him from buying astutely for the Society, both in a Bloomsbury range of pictures by Vanessa Bell, Simon Bussy, Duncan Grant and Nina Hamnett, and in 1948 works by Frances Hodgkins, Edward le Bas and William Scott.

Besides the two outstanding acquisitions of the immediate postwar period from Marsh and Clark, several other groups of works deserve to be singled out, each speaking clearly of distinctive preferences. For example, S. E. Thornton bequeathed his collection in 1944; it was founded on traditional values represented by such artists as Muirhead Bone, D. Y. Cameron, Philip Connard, and enlivened by landscapes by Spencer Gore and S. J. Peploe. A taste which had become unexceptionable by the 1940s was that shown by E. M. B. Ingram, whose bequest included two works by Matthew Smith and a painting of Dieppe by Sickert, all of such quality as to be selected for the Society's fiftieth anniversary show in 1960. The committee was more exercised by the request in 1941 of Miss A. F. Brown to accept *in toto* a group of works, which they did with just a faint demur. Miss Brown's taste was for abstraction, and her gift included a carving by Moore and a design by Ben Nicholson.

The wider world of contemporary collecting in Britain was more international. For example, in 1947 the inaugural show of the Institute of Contemporary Arts, called '40 Years of Modern Art', featured many works from the School of Paris, including those owned by E. C. Gregory, E. L. T. Mesens, Peter Watson, Herbert Read and Roland Penrose. Some of these have directly or indirectly found their way into British collections, notably the Tate.

As has been explained, it had not been a main intention of the Society to buy or support purchases of foreign art. A modest international role was only accepted because of inadequate British gallery funding. Even the Tate Gallery needed to ask the CAS to make a contribution to purchases of works by a number of foreign artists. Between 1940 and 1960 money from the Foreign Fund helped acquisitions of paintings by Jankel Adler (though his residence in Britain perhaps hardly justified his being called foreign), Masson and Jean-Paul Riopelle, and works in other media by Sam Francis, Klee and Giacometti (as well as those from the Sadler collection by Rouault and Modigliani). The Society was

also prepared to assist in an emergency, as in 1945 when, together with the National Art-Collections Fund, it helped the gallery to buy Matisse's portrait of Derain.

Nor had the Society intended from the first to support collections abroad, despite an early foray on behalf of Johannesburg. In the 1940s, however, there was a feeling that it would be an advantage if British artists were better known abroad. Acting on this, John Rothenstein on a trip to New York arranged for the Museum of Modern Art to be given *The Nursery* by Stanley Spencer.

There were also subscriptions to the Society from countries in the Empire. The Art Gallery of New South Wales started to subscribe in 1941; it was a subscription rewarded by £1,000 worth of works. Other galleries in the Commonwealth also joined the Society after the war. The bounty of the Marsh collection was shared with many galleries in the Commonwealth: Adelaide, Brisbane, Melbourne and Perth in Australia; Auckland, Bishop Suter and Dunedin in New Zealand; Montreal, Ontario, Toronto and Vancouver in Canada were among those who received works from the Marsh bequest.

This internationalism also applied to other acquisitions, so that works bought from the Society's exhibition 'The Seasons' in 1956 included *Winter Harbour* by Patrick Heron which went to Vancouver, and *The Seasons* by F. E. McWilliam which found a home in Perth, Australia.

Three exhibitions

A further activity for the Society was arranging exhibitions; the 1950s saw three such ventures; 'Figures in their Setting' for the Coronation year, 1953, followed by 'The Seasons' in 1956 and 'The Religious Theme' in 1958. The first show proved quite controversial, as the works to be submitted were supposed to be figurative, not abstract. Lord Methuen recommended that William Brooker should be invited; 'If you don't know his work, there are some on show at the moment at Tooth's; and the Leicester Gallery usually has some. He is not abstract: and I gather from what I have learnt from the prospectus that abstract paintings are "out".'

Other letters from artists were more heated. Clifford Ellis and his wife made a sensible point with clarity:

Neither we, nor, for example, some of our French friends, consider that our recent work is 'abstract', but it is possible that other people might have different views.

In any case, we regret the phrase 'as opposed to', with its implication of sectarianism; surely this is alien to the spirit of the C.A.S.?

Nevertheless, the exhibition went well enough for the idea of a show to be renewed in 1956. There were fifty-seven artists who accepted an invitation to

[75]

contribute to 'The Seasons'. The ingenious system of patronage was that the Society agreed to purchase works to the value of £1,000, and offered help to public galleries who wished to make purchases. A *Torso* by Reg Butler given to Manchester and a *Winter Still Life* by William Scott given to the Tate Gallery were among the works bought in 1956. But the heat generated by the terms of the former show still lingered; for example, Ben Nicholson wrote a wary reply to his invitation: 'There was some kind of prize awards as well wasn't there – and if so I wonder who the judges are selected from – presumably the Contemp. Art Society's committee? – but that could mean almost anything as so many differing points of view exist within that society ...'

The third show of the trio, 'The Religious Theme' in 1958, started with a disadvantage as some artists were reluctant to tackle the subject; but eighty artists accepted the Society's invitation. As in the other cases, part of the attraction for artists was that the Tate Gallery provided the initial showing, and the exhibition then toured.

A changing market and public collections

These exhibitions show the Society adapting to new conditions in the 1950s, though the art collecting community was still quite small and closely knit. In 1956 Pauline Vogelpoel succeeded Denis Mathews as the Society's Organising Secretary; she remembers how people joined the Society to know what was going on; and they turned up to the Society's private views because they were important events. Those were days before television had become an agent of artistic publicity.

Oliver Brown at the Leicester Galleries, who could recall World War I, was surprised by 'the vogue of the one-man show' in which his gallery and 'perhaps no more than half a dozen other galleries' had specialized before 1939.[13] Shows in which well-known and hopeful artists mixed had been more normal. They still had a place in the 1950s as was clear from the long life of the Leicester Galleries annual, cheerfully known to an in-crowd by an adaption of its title as 'Artists of Shame and Compromise'.

Three significant modern commercial galleries had been founded just after the war: Gimpel Fils, the Hanover Gallery, and the Marlborough Gallery. They were all international galleries by the 1960s, a fact reflecting the new market for British art abroad, both in the United States and Europe. The Marlborough Gallery in addition was well financed, and started a policy of paying an artist a salary, which drew away talents from competitors. The career of Francis Bacon is a case in point. The early purchase in 1946 of his *Figure Study II* by the Society's buyer, Colin Anderson, is a justified source of pride; in 1957 it was the R. J.

[76]

Sainsbury Discretionary Trust which purchased four works from Erica Brausen at the Hanover Gallery, but despite her fostering of his painting, Bacon was soon afterwards taken up by the Marlborough.

Besides, British artists no longer looked only to Paris for inspiration by the end of the 1950s; America was in vogue. The Tate Gallery in 1956 and 1959 had put on major shows of American art, and Bryan Robertson had organized in 1958 a startling and influential exhibition of the work of Jackson Pollock. It was one of a major series of foreign shows which he organized at the Whitechapel Art Gallery in the 1950s; Mondrian 1955, de Staël 1956, Pollock 1958, Malevich 1959, Rothko 1961, Poliakoff 1963, Rauschenberg 1964, Johns 1964; and as for British art, he gave valuable shows to artists in mid-career.

It is easy to see the practice of the Society and the policies of art museums as intertwined during the 1950s. Both gallery directors and critics were firmly represented on the Society's committee, for example Sir John Rothenstein of the Tate, Bryan Robertson of the Whitechapel, Loraine Conran of Kenwood, and the Director of the National Gallery, Sir Philip Hendy, who had come from Leeds City Art Gallery; critics who were also buyers included Robin Ironside and Eric Newton.

In collecting policy the Society had an edge on public galleries; there was no question of being morally obliged to buy works to 'fill gaps', since the Society had no collection of its own. A buyer's brief was to buy for quality. In contrast, a curator had to keep in mind the ultimate character of the collection, weighing current purchases against possible future benefactions. For the lucky curator the benefactions materialized; the generosity of the Misses Davies to the National Gallery of Wales, the Maitland gift and then his bequest to the Scottish National Gallery of Modern Art, and the McInnes collection for Glasgow are exemplary. But things could go wrong. T. J. Honeyman was a distinguished director, whose background as a dealer proved to be much to Glasgow's advantage; but the city's failure to act effectively to house Sir William Burrell's collection antagonized at least one collector. There is a fine Burrell gallery now, but William Cargill's collection has been forever lost.

One museum was exceptionally fortunate in its relations with the Society. The British Museum's Print Room was a major beneficiary. Campbell Dodgson was the Keeper until 1932, and from 1919 had the assistance of a Prints and Drawings Fund, separately subscribed within the CAS, to build up the collection. He was succeeded by A. M. Hind, who retired in 1945, when the committee reviewed this special fund's buying policy. The Keeper had until then had a free hand; as Hind put it, the fund had been administered by him 'without further authority from the committee' (see also p.60). The distinction of the British

Museum's twentieth-century collection thus owes much to the Society; other collections only benefited from a quarter of the fund. The committee decided in 1945 that the Society's buyer for the year should take over buying for the Prints and Drawings Fund. The Fund was merged into the Society's General Funds by December 1954.

A lesser-known activity since 1928 was the Pottery and Crafts Fund, chaired by Ernest Marsh until his death in 1943. This used modest funds for building up representative collections of the crafts in major centres. The roll call of work purchased is remarkable, and the job of the fund was at no time more significant than during the war. Ernest Marsh in his first wartime report wrote: 'I have tried to help some of our hard-hit craft workers as far as my funds permitted.' And in the next report he stressed the importance of the fund: 'There is a great danger that after the war there will be few crafts people left in existence when their activities will be more than ever required in the period of reconstruction, unless some relief is afforded to enable them to carry on now and to train others in preparation for the work ahead.' In 1942, Bristol received Battersea glass, and ceramics by Hamada, Bernard Leach and Michael Cardew. More than twenty other centres received significant gifts during the war, including the Victoria and Albert Museum, Aberdeen, Hanley, Liverpool, Manchester and Southampton. Lady Sempill was the second buyer for the fund, which had ceased to function by 1949.

There were two public collections for which the Society needed to feel no responsibility, those of the Arts Council and the British Council, both financed from the Treasury. Both grew in size and importance during the 1950s, their exhibitions taking on an increasingly important role at home and abroad. Comparison between purchases made for the Society and the two Councils shows how the governmental organizations were able to buy from a much larger number of artists; the appropriate parallel is with the war artists' scheme, some of whose works, incidentally, were distributed to these two collections.

The 1950s did not see corporate collecting emerge, though the breweries continued to commission pictures 'Recording Britain' after the Pilgrim Trust money ran out. Two new educational levels of patronage emerged, for schools, encouraged by an exhibition 'Pictures for Schools'; and some colleges followed the lead of Pembroke College, Oxford in using subscriptions from undergraduates for buying works of art.[15] As to larger projects, there was some committee discussion at different times about major commissions, or collaborating with architects, though these did not go far. It was not until the next decade that bigger changes were to come, even if Pop art was incubated during the 1950s by the Independent Group, and had made an appearance in the 1956 show called 'This is Tomorrow', opened by a robot at the Whitechapel.

Sidney Nolan b.1917
Death of a Poet 1954
ripolin on masonite, 101.6 × 128.3 cm
purchased by Peter Meyer, 1957
presented to the Walker Art Gallery, Liverpool, 1959

A golden year

In 1960 the CAS celebrated its fiftieth anniversary, suitably marked by a resplendent exhibition at the Tate Gallery. The trophies collected by the Society since 1940 were especially fine. The Marsh bequest and the Clark gifts shone brightly among the chosen watercolours and drawings, but everywhere the buyers' discrimination was made plain.

Sir Colin Anderson, who had made the momentous choice of Francis Bacon's *Figure Study II* in 1946, was also represented by his choice of a picture by Robert Colquhoun, *Woman with a Birdcage* from Bradford. W. A. Evill, an important collector in his own right and a firm supporter of Stanley Spencer, had also chosen an early picture by Bacon in 1952, *Pope I*, given to Aberdeen. Sir John Rothenstein's choices included a Philip Wilson Steer from 1900, *Reclining Nude*,

bought in 1941, and presented to the Tate; the Tate's interests had also been considered in the case of a first picture for the collection by Peter Lanyon, *Porthleven*, chosen in 1951 by Sir Philip Hendy. E. C. Gregory, whose foreign pictures and sculptures were to be a welcome and much-needed addition to the Tate's collections at his death, was represented by his purchase in 1953 of *Homage to Beethoven* by Ceri Richards, presented to Cardiff. The Secretary at that time, Loraine Conran, was identifiable as the buyer of paintings by Alan Davie in 1956, *In the Face of the Witch*, and by Merlyn Evans in 1955, *Window by Night*, both then still in the possession of the Society. The Treasurer of the day, Peter Meyer, was represented by his 1957 choice of pictures by Ivon Hitchens, *Evening Sky over Hills*, from Eastbourne, and Sidney Nolan, *Death of a Poet*, painted in 1954. Mrs Oliver Parker's choice of *October Red Wedge* by Terry Frost had been made in 1958, and other abstract work included *Motif in Indian Red and Yellow* by Victor Pasmore, bought in 1955 by Howard Bliss.

The exhibition was a vindication of an open-minded policy and distinctive generosity; the CAS had sound and comprehensive reasons for a celebration.

Notes

1. Kenneth Clark, *The Other Half* (London, 1977), pp.2,5
2. Brian Foss, 'British Artists and the Second World War' (unpublished Ph.D. thesis, University College, London, 1990), is now the authoritative account. Meirion and Susie Harries, *The War Artists: British Official War Art of the Twentieth Century* (London, 1983) is a general account of the schemes in both world wars.
3. David Mellor, Gill Saunders and Patrick Wright, *Recording Britain: A Pictorial Domesday of pre-war Britain* (Newton Abbot, 1990)
4. Clark, op. cit., p.22
5. Ibid., p.23
6. J. Ford (compiler), *Arts Council Collection, a* concise, illustrated catalogue (London, 1979), p.8
7. *Seventeen Collectors: an exhibition of paintings and sculpture*, Tate Gallery (1952), n.p. [18]
8. Ibid., n.p. [16]
9. Christopher Hassall and Denis Mathews (compilers), *Eddie Marsh* (London, 1953), pp.9,14
10. *Seventeen Collectors*, op. cit., n.p. [6]
11. Ibid., n.p. [10]
12. Ibid., n.p. [2]
13. Oliver Brown, *Exhibition: Memoirs* (London, 1968), p.128
14. T. J. Honeyman, *Art and Audacity* (London, 1971), p.130
15. Anthony Emery, 'A New Oxford Movement', *Studio* (January 1951), pp.14–17

Paul Nash 1889–1946
Landscape of the Moon's Last Phase c.1942
oil on canvas, 63.5 × 73.7 cm
purchased by Sir Edward Marsh, 1944
presented to the Walker Art Gallery, Liverpool, 1944

Cecil Collins 1908–89
The Sleeping Fool 1943
oil on canvas, 29.8 × 40 cm
purchased by John Rothenstein, 1943
presented to the Tate Gallery, London, 1951

Robert Colquhoun 1914–62
The Fortune Teller 1946
oil on canvas, 126.4 × 80.9 cm
presented by Sir Colin and Lady
Anderson, through the CAS, to the
Tate Gallery, London, 1976

Winifred Nicholson 1893–1981
Honeysuckle and Sweet Peas c.1946
oil on board, 44 × 71.7 cm
purchased by Sir Edward Marsh, 1946
presented to Aberdeen Art Gallery, 1949

OPPOSITE
Francis Bacon b.1909
Pope I 1951
oil on canvas, 198 × 137 cm
purchased by W. A. Evill, 1952
presented to Aberdeen Art Gallery, 1956

Francis Bacon b.1909
Study for the Magdalene – Figure Study II 1945–6
oil on canvas, 145 × 128.5 cm
purchased by Colin Anderson, 1946
presented to Batley Art Gallery, 1952

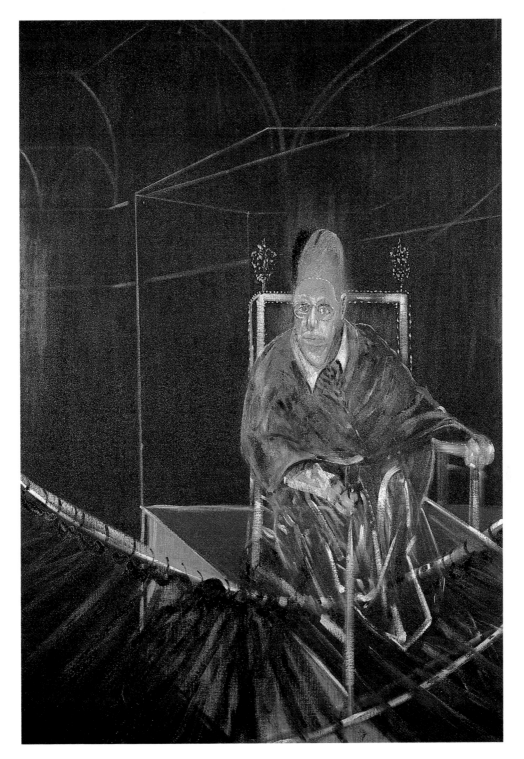

Ben Nicholson 1894–1982
Still Life 1950
oil and pencil on canvas, 203.2 × 228.2 cm
bought by private subscribers and CAS, 1953
presented to Manchester City Art Gallery, 1953

Peter Lanyon 1918–64
Porthleven 1951
oil on board, 244.5 × 121.9 cm
purchased by Sir Philip Hendy, 1951
presented to the Tate Gallery,
London, 1953

Merlyn Evans 1910–73
Wharfside Construction 1953
oil on canvas on hardboard, 83.5 × 91 cm
purchased by Peter Meyer, 1957
presented to Glasgow Art Gallery, 1959

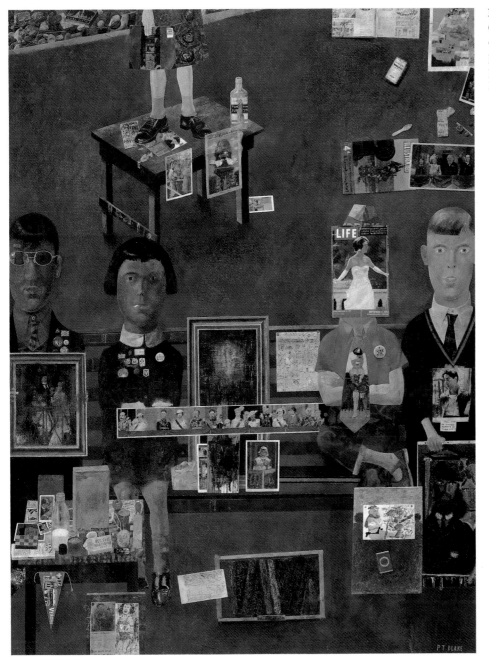

Peter Blake b.1932
On the Balcony 1955–7
oil on canvas, 121.3 × 90.8 cm
purchased by Bryan Robertson, 1959
presented to the Tate Gallery,
London, 1963

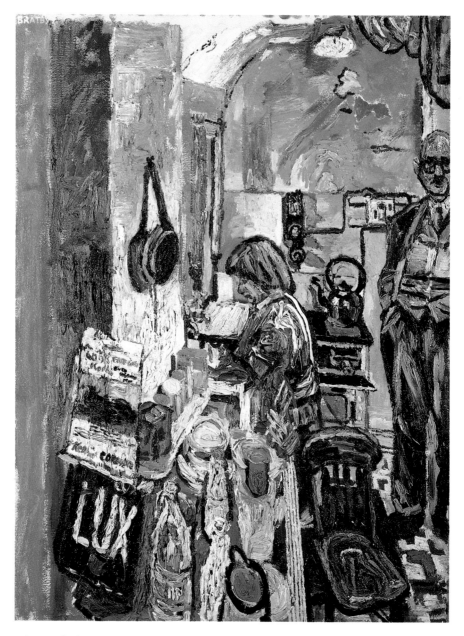

John Bratby b.1928
Kitchen Interior 1955–6
oil on board, 138.4 × 81.2 cm
purchased by Eric Newton, 1957
presented to the Williamson Art Gallery, Birkenhead, 1959

Frank Auerbach b.1931
Maples Demolition, Euston Road 1960
oil on board, 148.6 × 153.7 cm
purchased from CAS Exhibition 'British Painting in the Sixties', 1963
presented to Leeds City Art Gallery, 1964

William Scott 1913–89
Winter Still Life 1957
oil on canvas, 40.6 × 50.8 cm
purchased by Mrs Oliver Parker, 1958
presented to the National Museum of Wales, Cardiff, 1959

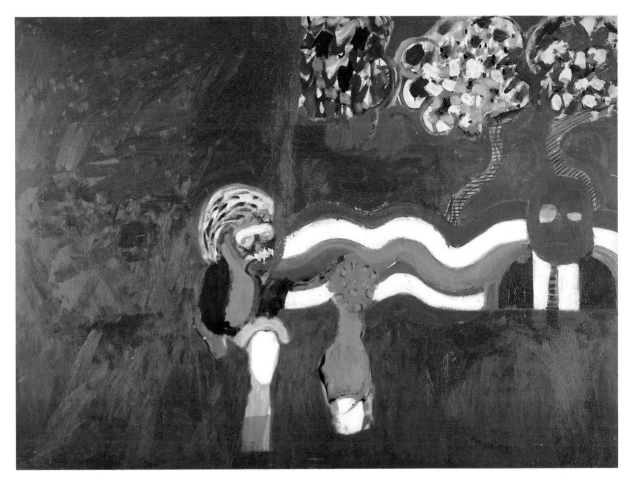

Howard Hodgkin b.1932
Staff Meeting 1960
oil on canvas, 111.8 × 152.4 cm
purchased from CAS Exhibition 'British Painting in the Sixties', 1963
presented to Kettering Art Gallery, 1964

Adrian Heath b.1920
Brown Painting 1961
oil on canvas, 188 × 162.6 cm
purchased from CAS Exhibition 'British Painting in the Sixties', 1963
presented to Glasgow Art Gallery, 1969

Roger Hilton 1911–75
March 1961
oil on canvas, 132 × 139.7 cm
purchased by Alan Bowness and Lord Croft, 1962
presented to the Whitworth Art Gallery, University of Manchester, 1968

Patrick Heron b.1920
Various Blues on Indigo 1962
oil on canvas, 101.6 × 152.4 cm
purchased by James Melvin, 1963
presented to the National Museum of Wales, Cardiff, 1964

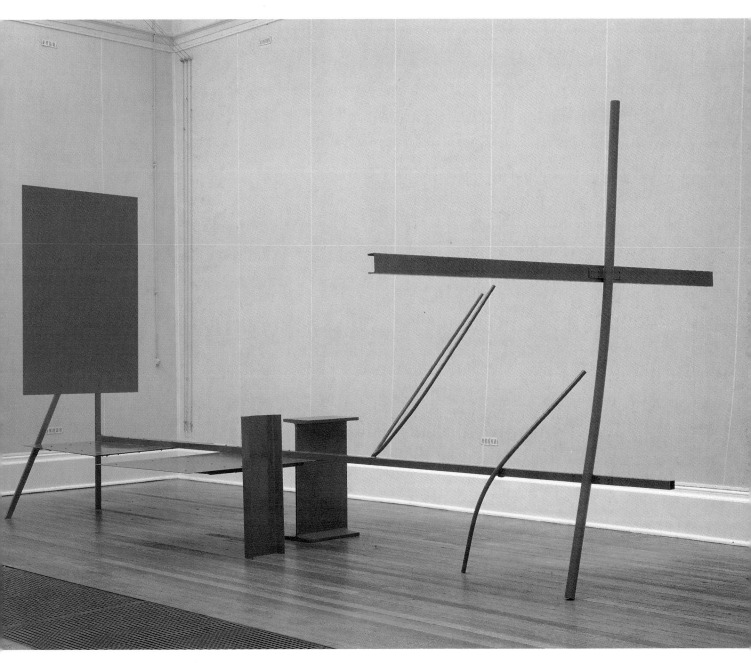

Anthony Caro b.1924
Early One Morning 1962
painted steel, 289.6 × 619.8 × 335.3 cm
purchased from CAS Exhibition 'British Sculpture in the Sixties', 1965
presented to the Tate Gallery, London, 1965

The Contemporary Art Society in the sixties and seventies
Margaret Garlake

Discussing the Contemporary Art Society's approach to buying at the end of the 1970s, Lord Croft was critical of its reluctance to acquire new artists; he felt that it had become unadventurous.[1] Yet it had not, as he remarked, always been so. If buying practice had changed, so, to a much greater extent, had the Society itself. In two decades it had been transformed from a socially prestigious club, grounded in the principles of enlightened private patronage, to an agent of corporate collecting, offering advice to companies on buying art in return for contributions to the purchase fund.

Having spent much of the preceding twenty years struggling to come to terms with a rapidly changing art world, the Society had, despite the misgivings of the committee, found a new identity. These years had seen the development of 'Happenings', Kinetic art, Minimalism,[1a] Conceptual art,[1b] concrete poetry,[1c] fine art photography, Pop, Performance, installation, environmental art, holography, video and 'non-objective' art.

It was a period when the structure of patronage changed as radically as the art it served. When the old structures of patronage and support proved inadequate, artists established their own exhibiting spaces, agencies and publications. They even briefly swept away the hierarchic order that brought authority to the art educators and the adjudicators of great international exhibitions. At the other extreme, institutions like the Arts Council became richer and more powerful. By 1965, when Jennie Lee was appointed the first Minister for the Arts, artist-led interventions into the market/patronage system were well under way alongside a plethora of new commercial ventures.

The Society had not only to redefine its role but to confirm the need for its existence at a time when it was also suffering from diminishing membership and an inadequate income. With the tiny sums available to its buyers,[2] it needed, as it had always done, to buy cheaply ahead of market trends, but much of the new art seemed to be unsuitable for presentation to museums. Yet although the CAS remained ineluctably centrist, it did come to terms with its context, not least because of the imagination and energy of Nancy Balfour. Through its committee and members, the Society was integrated into the network of relationships that

Mary Potter 1900–81
Reflected Patterns 1974
oil on canvas, 76 × 91.3 cm
purchased by Marina Vaizey, 1975
presented to Batley Art Gallery, 1979

general rule is, of course, for buyers to be guided by their own predilections and perceptions of suitability. Most spread their selections very wide. In 1966 when Loraine Conran bought William Tucker's *Meru 2*, one of a series of three sculptures which form variants on symmetrically opposed rectilinear and curved silhouettes, he also chose a portrait by Frank Auerbach and a painting by Peter Joseph, who caused a sensation when he showed his 30-foot-long *Colour Continuum* at Signals the same year.

A few concentrated narrowly, like Alistair McAlpine, a famous patron of New Generation sculpture, who in 1971 bought only five works. Three were paintings by the Cornish naive artist and father of the modern St Ives school, Alfred Wallis, but the prize piece was Peter Blake's proto-Pop collage, *Tattooed Lady* (1958), one of a long series of circus subjects, now in the V&A. The architect Max Gordon also made an extremely idiosyncratic selection in 1974, largely of minimalist works which included prints by American artists then little known in this country: Brice Marden, Agnes Martin, Bruce Naumann and Richard Serra, with a drawing by Dorothea Rockburne constructed from gummed labels.

The purchases made by Lord Croft and Alan Bowness in 1962 illustrate the topicality that the Society's buyers sought. The pre-eminence of 'Situation' painting was marked by John Hoyland's *Number 22* as well as by the Cohen brothers, Gillian Ayres and John Plumb. *The Third Big Bus*, a diagonal 'shaped' canvas with an appendage at the bottom for the vehicle's wheels, by Allen Jones, represented Pop with some panache. Roger Hilton's *March 1961*, an engaging and important painting which combines luscious paint with the artist's spare graphic style, represented the St Ives school, eagerly sought by dealers and collectors.

Considerably less familiar to a British public was the work of Otto Piene, a member of the German Zero Group,[15] who were to receive their first group showing in this country at Denis Bowen's New Vision Gallery in 1964. Piene, whose *Red Smoke Drawing* was chosen by Alan Bowness, was concerned with the effect of fire on painting; his colleague, Gunther Uecker, made reliefs with nails which featured among subsequent acquisitions. There was no stipulation to 'buy British' and a haphazard, if not undistinguished selection of work by Continental and American artists was acquired, which included such luminaries as Georges Mathieu and Adolf Gottlieb.

The works bought in the last years of the 1960s signalled acknowledgements of change. Successors and challengers to the New Generation aesthetic had emerged among such performance-based St Martin's students as Barry Flanagan. His *Sand Muslin 2* (1966) and *Rope 8* (1968), sculptures whose titles describe their constituents, were bought by David Sylvester in 1969, together with the Society's first concrete poem, Ian Hamilton Finlay's *Drift*. It was a memorable year for

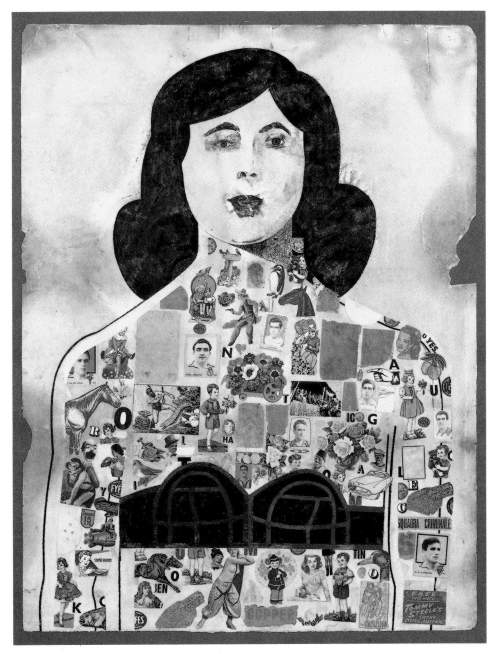

Peter Blake b.1932
Tattooed Lady 1958
ink and collage, 68.6 × 53.3 cm
purchased by Alistair McAlpine, 1971
presented to the Victoria and Albert Museum, 1972

Bruce McLean b.1944
Study for *The Object of the Exercise* 1979
acrylic on paper, 142.2 × 166.3 cm
purchased by Gabrielle Keiller, 1980
presented to Southampton City Art
Gallery, 1982

OPPOSITE
John Hoyland b.1934
Trickster 1977
acrylic on canvas, 228.6 × 213.3 cm
given by The Linbury Trust, 1978
presented to Swindon Art Gallery,
1982

purchases, among them John Hoyland's *Painting 12.1.1969* which was lent to his exhibition at the São Paulo Bienale; a group of screenprints by Patrick Caulfield, who had shown at São Paulo two years earlier and a painting, *London Study* (1968), by Mark Boyle, who had recently provided the first solo show for the rehoused, refurbished ICA after its move to Carlton House Terrace, and was soon to be famous for his territorial simulacra.

But much of the new art presented intractable problems; the heyday of Pop was over; sculpture had dissolved into assemblages of alarmingly unconventional materials; the ever-widening gap between the artist and the non-expert consumer was to become apparently unbridgeable with 'The Art of the Real'.[15a] Few buyers were prepared to commit themselves as unequivocally as Max Gordon and instead often opted for older-established artists and media.

When Marina Vaizey and Edward Lucie-Smith were buyers in 1975, they skirted this problem and solved that of ever-rising costs, by virtually confining themselves to works on paper. Within this limitation their selections covered a gamut of media from watercolour to modified photography and artists as disparate as Michael Craig-Martin and John Loker, Elisabeth Vellacott and Carl Plackman, Mary Potter and Rita Donagh.

Photography remained firmly on the margins of the Society's purchases until 1977 when Joanna Drew and Lord Dufferin both made it the focus of their selections. While Fay Godwin's *Sheepfold, Aberedw Hill* represented classic landscape photography, Ian McKeever's *Near Cromer, Norfolk, Summer 1977*, one of a series of double works which juxtaposed photography and drawing, annexed the medium in a modification of landscape painting. Nigel Henderson, until recently a neglected pioneer of experimental photography, took the human head for his principal subject. *Face at the Window 1* is one of three prints derived from a head featured in a set of Wills' cigarette cards which dealt with first aid.[16]

The Society had ended the 1960s beset with financial problems: membership was dropping and the Friends of the Tate, recently expanded, presented a serious threat to social exclusivity and membership. In 1973, when administration costs swallowed half the income, John Sainsbury suggested that it might be time to wind up the Society, since its simple purpose, to buy works of art, was clearly not being efficiently fulfilled.[17] However, the Arts Council agreed to give a purchase grant of £2,000[18] and plans were mooted for an Art Fair, a forerunner of the Markets which have been so successful in recent years. The first one took place in the Mall Galleries early in 1975 and contained one work each by 150 artists, from gallery stocks. Many museum directors attended a special lunch to meet dealers and the Society made a modest profit, although only a tiny number of works was sold.[19]

In 1977 the Scottish Arts Council undertook to make a grant for the purchase of Scottish art.[20] Gabrielle Keiller, well known as a collector of Eduardo Paolozzi's work, made the selection, which included a print and three 'glass poems' by Ian Hamilton Finlay. *Sea Poppy I* and II (1968), now in the Tate, are glass sheets on which the names and port numbers of fishing boats are engraved in a concentric pattern.[21] Eileen Lawrence's *Prayer Stick I* (1977), bought at the same time, was also given to the Tate. A mysterious and evocative piece, it is constructed of handmade, recycled paper into which the artist incorporated tiny fragments of birds' eggs and feathers.

Nancy Balfour, a collector and, until 1972, American editor of *The Economist*, was invited to join the committee in September 1966 and chaired it from 1976 to 1982. Devoted to the Society, as to the artist-generated support schemes with which she was already deeply involved, she was also a member of the Regional Committee of the Arts Council, in which capacity she was able to generate a great deal of support for the CAS.

However, it was the corporate membership scheme that was to retrieve the Society's fortunes. Pauline Vogelpoel, the infinitely energetic Organising Secretary, had suggested that the Society should buy on behalf of corporate collections and in 1976 Nancy Balfour set up a sub-committee to investigate business support for the Society, proposing that companies might buy experimental works for presentation, while the Society would reciprocate with loans or advice on purchases of art for their collections.[22] A few months later Pauline Vogelpoel helped Mobil to buy prints for its new London building, which brought the Society a donation of £1,000 and in 1977 the first important corporate contract was set up with De Beers. By the end of the decade the Society had thirty-six corporate members, paying substantial subscriptions, while those from commercial galleries, initiated in 1970, were increasing steadily.

At the same time Nancy Balfour persuaded the Gulbenkian Foundation to offer a two-year grant for expansion[23] which made it possible to employ Petronilla Silver as a much-needed full-time assistant. By the end of the 1970s the Society was firmly aligned with commerce and set to survive. It had quietly modified its orientation: members still made lavish overseas visits but they also took day trips to the SPACE studios at Shad Thames and Deptford, to the Open Studios show at Wapping and to the House Gallery.

'… the Society should buy more boldly'[24]

Despite the Society's welcome financial regeneration, some members of the committee felt that its *raison d'être*, to buy exciting new art, had been abandoned. When Lord Croft pleaded in 1979 for greater boldness, he noted that most of the

OPPOSITE
John Walker b.1939
*The Shape and the Disgruntled Oxford
Philosopher* 1979–80
oil on canvas, 211 × 184 cm
presented by Nancy Balfour, 1980
presented to the Whitworth Art
Gallery, University of Manchester,
1982

RIGHT
Lucie Rie b.1902
Stoneware Bowl and Bottle 1980
bowl 33cm diameter
bottle 30.5cm high
purchased by Carol Hogben, 1980 ·
presented to the National Museum
of Wales, Cardiff, 1982

Bill Woodrow b.1948
Twin-Tub with Beaver 1981
twin-tub washing machine and
woodgrained plastic covering,
height 78.9 cm
purchased by David Brown, 1982
presented to Leeds City Art Gallery,
1986

artists in recent acquisition lists had first been bought by the Arts Council; to buy 'safely' was a denial of the CAS's independence.

Looking back, the prescience of buyers and their coverage of the contemporary mainstream in the early 1960s are remarkable. Later in the decade, attempting to reconcile radically new media and materials with the inherent conservatism of museum curators, they often sidestepped the issue of experimental art. By the mid 1970s, there is a discernible tendency to support the established rather than try to establish the unknown.

Nevertheless, the Society has capitalized with great perspicacity on its position at the junction of so many disparate paths within the art world, the resource that enables it to supply galleries serving diverse communities all over the country. How it has reconciled the homogenizing influence of corporate patrons with its incomparable asset, the strong individual voices of buyers, is the story of more recent years.

Acknowledgements
I would like to thank Nancy Balfour, Alan Bowness and Bryan Robertson for their help and much information about the Society. Peter Sedgely and Barbara Steveni very generously gave me access to their archives; Jack Wendler and Letty Mooring provided invaluable ideas and information. I am most grateful to all of them.

Notes

1. Minutes, 12.11.79. Lord Croft was a member of the CAS committee and a renowned collector of modern British art.

1a. See Note 15a.

1b. See Note 15a.

1c. A conjunction of text and object in which verbal and visual distinctions are transcended in the formation of a new category where words are to be read both as text and physical objects.

2. £2,500 in 1961, of which £30 was earmarked for prints and drawings; £4,000 in 1963, with an extra £3,000 allocated for purchases from 'British Painting in the Sixties'; £11,476 in 1965, a sum made possible by a £5,000 bequest; £5,000 in 1966; £4,000 in 1969; £6,000 in 1972; £10,000 in 1974; over £16,000 in 1976, when funds began to rise sharply with increased grants. They were subsequently augmented by corporate contributions.

3. Minutes, 22.9.70

4. 'Air art' was shown under the auspices of the Centre for Studies of Science in Art; Dom Sylvester Houedard provided the concrete poetry and Margaret Benyon the holography.

5. Which also included Bridget Riley, Richard Hamilton, Peter Blake, Patrick Caulfield, David Hockney and Mark Lancaster, all represented among CAS purchases.

5a. 'Situation' was organized by a committee of artists, chaired by the critic, Lawrence Alloway, in order to give artists whose work was too large to be acceptable to commercial galleries an opportunity to exhibit. The rules stipulated that paintings should be totally abstract and not less than 30 sq. ft. A second 'Situation' exhibition took place at the Marlborough New London Gallery in 1961 and an Arts Council version toured in 1962/3.

6. Space Provision (Artistic, Cultural and Educational) Ltd.

7. Sedgely won the Minister of Education's Prize at the 1967 Tokyo Biennale, where he showed with Tess Jaray, Marc Vaux and John Plumb, all of whom appeared in CAS purchase lists.

8. Its companion scheme, AIR (Artists' Information Register), launched with 'the express intention of playing Robin Hood to the artworld' (*Art & Artists*, 10,2, January 1968), developed into an

invaluable resource with its own gallery.

9. Edward Lucie-Smith, cited in the Minutes, 12.11.79

10. Nikos Stangos (ed.), *David Hockney by David Hockney*, (London, 1976), p.64

11. Documented in R. Hamilton, 'Five tyres remoulded', *Studio Int.*, 183, 945, June 1972

11a. Director of the Whitechapel Art Gallery 1952–68. During his term of office the gallery was the principal venue in Britain for solo shows of continental and American pioneers of contemporary art (see p.77). Robertson also organized a notable series of retrospectives by contemporary British artists, which included Barbara Hepworth 1954 and 1962; Alan Davie, 1958; Kenneth Armitage, Jack Smith, 1959; Ceri Richards, Prunella Clough, 1960; Keith Vaughan, 1962; Bryan Kneale, 1966; John Hoyland, 1967; Philip King, 1968.

12. William Feaver, quoted in *Sean Scully*, Whitechapel Art Gallery, 1989, p.11

12a. Vaux commented: 'I have omitted from my work things like compositional choice and shape, so far as that is possible – and texture, apart from what comes about by actually putting the paint down.' ('From a discussion between John Plumb and Marc Vaux', *Studio Int.*, 185, 956, June 1973.)

13. 16.7.63

13a. The ground-breaking 'New Generation' sculpture exhibition in March 1965 showed a group of artists trained at St Martin's, whose mentor was Anthony Caro. The sculptures, in highly coloured steel or fibreglass, reversed the Henry Moore inspired aesthetic of the previous decade. Placed directly on the floor, without plinths, they wittily confounded conventional expectations of subject matter and solidity. John Richardson commented on the CAS show: '*Early One Morning* ... makes the nearby Hepworths look as dead as dodo's eggs ... refreshingly sparse after the sentimentality of Herbert Read's angst-peddling sculptures of the Fifties.' ('Carissimo', *New Statesman*, 12.11.65, quoted in William Rubin, *Anthony Caro*, (New York, 1965))

14. While the catalogue introduction described the Tate section as 'An exhibition organised by the CAS in association with the Peter Stuyvesant Foundation', the writer explained that the two parts had only a 'somewhat nebulous' connection as the Whitechapel section 'follows the trend established by the "New Generation"... sponsored by the Peter Stuyvesant Foundation'. The Society was to buy from both exhibitions, but the Foundation was to have first choice at the Whitechapel. (Minutes, 12.10.64.)

15. The Zero Group became prominent in Germany in the late 1950s when they held their first exhibitions by night, in Piene's studio. The 'Seventh night' was devoted to 'red painting'. (Cyril Barrett, 'Group Zero', *Art & Artists*, 1, 9, December 1966.)

15a. Organized by Eugene Goosens for the Tate Gallery, 1970, this exhibition introduced Minimalism to Britain from the United States. The exhibitors included Ad Reinhardt, Jasper Johns, Frank Stella and Kenneth Noland as precursors, with Carl Andre, Donald Judd, John McCracken, Doug Ohlson, Robert Smithson, Sol LeWitt, Robert Morris. 'When Attitudes Become Form', organized by Harald Szeemann for the Kunsthalle, Bern in 1969 and amended by Charles Harrison for the ICA, London, with additional work by British artists, had proposed a denial of the necessity for the existence of the art work in concrete form as a logical extension of the reductions of Minimalism. It emphasized process over medium and the primacy of the concept over the object, resulting in apparently irrational paradoxes or works which existed only as textual notations.

16. *Nigel Henderson*, Norwich School of Art Gallery, 1982, p.5

17. Minutes, 4.6.73

18. This rose to £3,000 in 1975 and £5,000 in 1976.

19. Minutes, 20.2.75

20. £1,000 plus £150 for the buyer's expenses. In 1978 this was increased to £1,500 with £200 expenses.

21. 'These were the earliest works of Finlay which in his view "extended concrete poetry off the page into object form"' (Tate Gallery, *Illustrated Catalogue of Acquisitions 1978–80*, p.93).

22. Minutes, 23.2.76

23. The Foundation offered £2,800 for 1977/8 and £1,850 for 1978/9, to be raised by the Society to £3,350 in each year, to cover the estimated cost of 'expansion'. Two anonymous donors provided the shortfall.

24. Lord Croft, cited in the Minutes, 12.1.79

Tony Cragg b.1949
Union Jack 1981
blue and red found plastic objects, 300 × 440 cm
purchased by Alan Bowness, 1981
presented to Leeds City Art Gallery, 1982

[124]

Gilbert & George b.1943 b.1942
Good 1983
Photo-piece, 242 × 151.5 cm
purchased by Marina Vaizey, 1984
presented to Wolverhampton Art
Gallery, 1986

The Contemporary Art Society and the eighties Marina Vaizey

The 1980s! The decade figurative and representational art came back, or rather emerged again (the myth suggests) from the miasmic fog of critical disapproval; and everything else happened too. There was art hype, for new and old; art-market columns in the newspapers, sales on the front pages, and with the advent of *The Independent* newspaper, a Monday column dedicated solely to the contemporary art market. With newspaper colour supplements, new magazines from *The World of Interiors* to *Metropolitan Home*, and the expanding media, including, for example, 'The Late Show' (BBC) there was simply more coverage, more 'visuals'.

All of this was a process that had begun in the late 1960s, with the emergence of *The Sunday Times Magazine*, the activities of Bryan Robertson at the Whitechapel Art Gallery, which had brought seminal contemporary exhibitions to London, and the publication of *Private View*, a gorgeous and prescient book on the contemporary art scene, written by John Russell and Bryan Robertson, with photographs by Snowdon. By the 1980s, there were hundreds of artists at work in London, many of them colonizing the East End, where it was estimated there were more artists per square mile than anywhere else in Europe, or even America. There were more galleries than ever before. Major British Council exhibitions (or mounted with their support) such as 'Current Affairs', which was shown in eastern Europe and at Oxford's Museum of Modern Art (1987), 'The Proper Study' (India 1984–5), and 'The New British Painting' (America 1989–90), let alone such major retrospectives under the aegis of the British Council as those devoted to Lucian Freud (Washington, Paris, London and Berlin 1987–8) and Howard Hodgkin (Nantes, Barcelona, Edinburgh and Dublin 1990–91), have given a broad spectrum of British art a greater profile abroad. For one frenzied week every two years the entire contemporary art world of dealers, curators, critics, bureaucrats – and even artists – gathers in Venice for the Biennale, the longest running international contemporary art anthology in the world. Again, the British have been perceived as outstanding throughout the 1980s, a process that began as early as 1976 with the British pavilion devoted to Richard Long. In the 1980s, in the pavilion looking with charming incongruity rather like a tea-house designed by Lutyens, Barry Flanagan (1982), Howard Hodgkin (1984), Frank Auerbach (1986), Tony Cragg (1988) and Anish Kapoor (1990) have each made

a striking impact. The exhibitions were subsequently shown internationally.

Throughout the 1980s there has been no single 'ism', no dominant genera-tion, rather a succession of fads, follies, fashions and good art (sometimes but not always one and the same), when aesthetic battles raged, and prices climbed ever upwards.

For most of the 1980s, perhaps improbably, in London the Royal Academy was a leader in setting the critical pace. 'A New Spirit in Painting' at the Royal Academy in 1981 attracted international attention, and surprised everybody by becoming the opening salvo in a debate about contemporary painting in particular, and contemporary art in general. 'British Art in the 20th Century', 1987, was part of a series of major, controversial exhibitions at the Royal Academy devoted to examining country by country 'modern' art in all its diverse manifestations. 'German Art in the 20th Century' initiated the series in 1985, and 'Italian Art' followed in 1989. The RA claimed these were the first such mammoth survey shows covering such a long period for both Italian and German art, further bolstering the sense, improbable as it might seem, of London as a centre for modern art, in museum and exhibition terms at least. American art is planned for the 1990s.

The British show was particularly important for Britain, because it engen-dered a great deal of debate, some of the who's in, who's out variety, but more about the nature of the modern movement as interpreted by the curators, and about British art in general, and in particular; but also because upon its subsequent showing in Stuttgart, in the new art gallery designed by the British architect James Stirling, it became the first such anthology of British art ever to be shown in Germany, and its catalogue the first survey in German of the modern movement in Britain.

Throughout the decade the Tate held important exhibitions, individual retrospectives for European and British twentieth-century artists, and surveys of the modern period, historic and contemporary. The Tate, the Royal Academy and, perhaps surprisingly, occasional twentieth-century exhibitions in the Prints and Drawings gallery of the British Museum ('A Century of Modern Drawing from the Museum of Modern Art, New York'; 'Avant-Garde British Printmaking 1914–1960') as well as regular contemporary and avant-garde exhibitions at the Serpentine, Riverside, ICA, Hayward and, of course, the Whitechapel, ensured that throughout the decade there was an enormous menu of such art fare. The Barbican Art Gallery opened in 1982, and its emphasis too has been on twentieth-century anthologies.

Public art has grown apace. Throughout the decade there have been projects in the countryside: Grizedale Forest, Yorkshire Sculpture Park, the Forest of

Christopher Le Brun b.1951
Painting, February 1982
oil on canvas, 35.6 × 45.7 cm
purchased with a bequest from George Mitchell, Esq., CBE, 1988
coll. Contemporary Art Society

David Mach b.1956
Thinking of England 1983
HP Sauce bottles, water and Dylon, purchased with the aid of a grant
from the Henry Moore Foundation, 1983
presented to the Tate Gallery, London, 1986

Dean, the Scottish Sculpture Trust, among them. There has also been an urban revival, with perhaps more public sculpture commissioned than at any time since the Victorian era of civic pride. The Public Art Development Trust, based in London but with a national brief, fostered commissions of public art, and similar trusts were set up with more specific regional frameworks, for example, in Edinburgh, Birmingham and Wales. PADT also spearheaded the founding of the Public Art Forum (1985) as a national association for organizers of public-art programmes, not only commissioning and purchasing art for public places in and out of doors, but also such programmes as artists in residence. Culture in general and art in particular was seen as a regenerating force for inner city difficulties, economic and social. Thus hundreds of exhibitions and the re-opening of the MacLellan Galleries as an exhibition space for contemporary exhibitions were among the outstanding features of Glasgow's year as European City of Culture in 1990. Major art, including the biggest artist-designed public pavement (by Tess Jaray) is part of Birmingham's regeneration, physically centred on the mixed development in the city centre around Centenary Square.

British sculpture was particularly inventive and admired throughout the decade, and here a commercial dealer must be saluted. The commitment and efficiency of Nicholas Logsdail and his Lisson Gallery to a group of sculptors – Anish Kapoor, Richard Deacon, Richard Wentworth, Julian Opie, Bill Woodrow, Tony Cragg, Edward Allington, among others – gave rise to the nickname the Lisson School, a misleading phrase, as the art was so disparate. Richard Long, who had shown at the Lisson in the 1970s, was now with Anthony d'Offay: Long, Deacon and Cragg all won Turner Prizes at the Tate.

The pressure group Art and Architecture attempted to integrate working artists into building schemes. The Broadgate development by Liverpool Street station has an extraordinary collection of public sculpture, some bought off the peg, so to speak, some publicly commissioned. On site, in sight, there are important pieces by Barry Flanagan, Stephen Cox, George Segal (his only piece in this country) and Richard Serra (his only public sculpture in Britain). There are substantial pieces of art inside the Broadgate buildings too: Thérèse Oulton and Sol LeWitt are among the artists represented. It is also significant that the Saatchi Collection, exclusively dedicated to contemporary art, opened for regular showings of selected examples, in a series of one-person shows, in a magnificent ex-factory in, of all places, demure St John's Wood. The Saatchi Collection began as an international collection with no significant British holdings but by the mid to late 1980s had begun to collect an eclectic mixture of British art. It is not every collector who could buy Richard Wilson's 20:50, a magical installation which has to be constructed anew every time it is shown, filling a room half full of sump

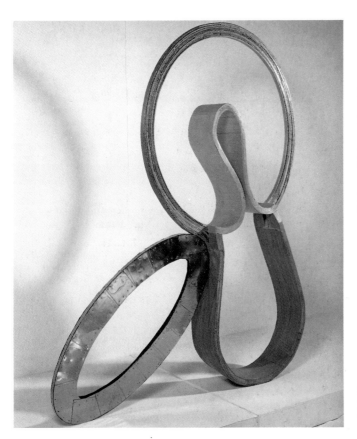

Richard Deacon b.1949
Mirror, Mirror 1983–4
laminated wood and stainless steel,
198.1 × 152.4 × 30.5 cm
purchased with the aid of a grant
from the Henry Moore Foundation,
1984
presented to Southampton City Art
Gallery, 1986

Broadgate Development, City of
London, showing sculpture *Fulcrum*
by Richard Serra

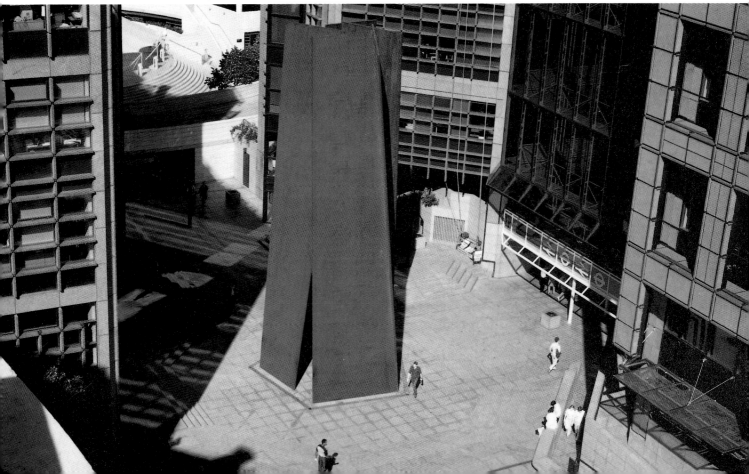

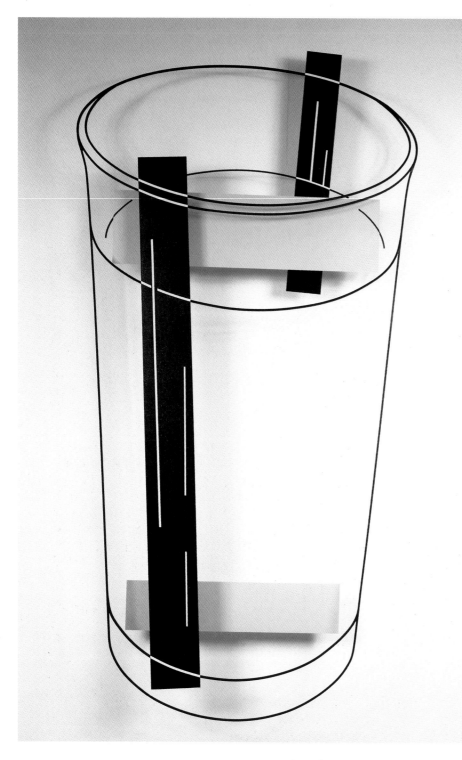

Michael Craig-Martin b.1941
Glass of Water 1984
oil on aluminium panels with
painted steel lines,
203.2 × 109.2 × 21.6 cm
purchased with the aid of a grant
from the Henry Moore Foundation
1985
presented to the Walker Art Gallery,
Liverpool, 1988
© Michael Craig-Martin 1991
All Rights Reserved DACS

OPPOSITE
Boyd Webb b.1947
Replenish 1984
Cibachrome, 153 × 121.6 cm
purchased by Jeremy Rees, 1984
presented to Salford Art Gallery,
1986

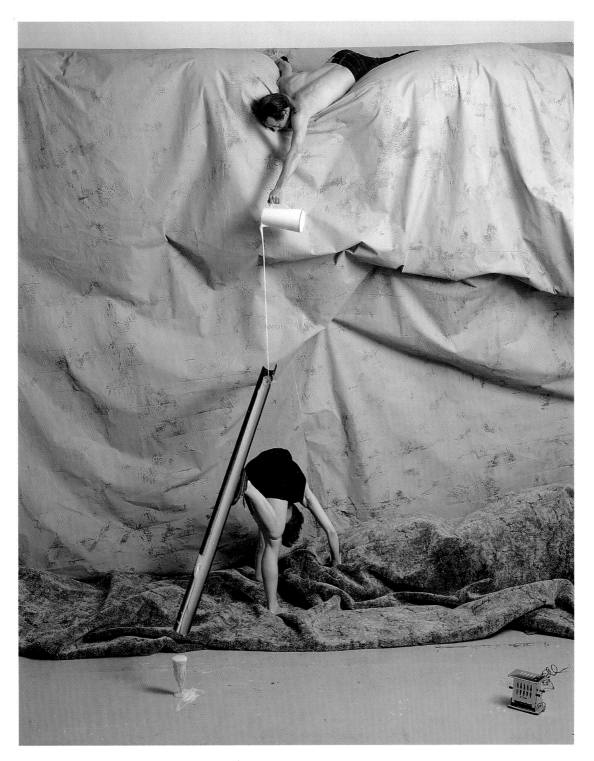

Richard Wilson b.1953
20 : 50 1987
used sump oil and steel
Saatchi Collection, London

First Contemporary Art Society
Market, held at Smith's Galleries,
Covent Garden, 1984

oil. By the late 1980s contemporary British figurative painting was so much discussed that the term School of London came into use, originally coined by the artist R. B. Kitaj for a drawing exhibition that he selected for the Arts Council as far back as 1976.

The CAS became in the 1980s a major adviser to corporate art collections, working with, among others, ICI, the Central Selling Organisation, Unilever, and Stanhope Properties plc. Nor were private collectors, particularly those just embarking, neglected. The Art Market, initiated by the CAS at Smith's Gallery in Covent Garden, fostered the notion of the art takeaway, with witty sponsorship by Sainsbury's. The CAS Market, selling hundreds of original art works in four or five days, has grown from a turnover of about £50,000 in 1984, the first CAS Market, to over £320,000 in 1990. CAS-run courses for new collectors, also initiated in the 1980s, were consistently over-subscribed.

Although the CAS has injected into the art market in the 1980s, as catalyst, and organizer, the purchasing of hundreds of major, and domestic, works of art by the private and corporate sector, its main purpose remains as ever the acquisition and purchase of contemporary art for public museums and galleries.

The art market has changed, of course. Until the recession of the early 1990s, it had seemed on an unstoppable curve, ever upwards. While van Gogh, Picasso, and the Impressionists and Post-Impressionists made astronomic prices, and the prices made headlines, the living also made records. In 1988 a Jasper Johns made $17,050,000 with buyer's premium, at Sotheby's, New York, then a record for any contemporary work of art and for any living artist; and in 1989 that record was broken by a Willem de Kooning, a painting called *Interchange*, also at Sotheby's, New York, at $20,680,000. The art market, or at least its auction houses, was then on what seemed a permanent high, of hype, media attention and dollar signs.

In parallel, the 1980s saw a resurgence of interest in British art probably only paralleled at the commercial height of the nineteenth century; and for the first time British art has been perceived internationally. Although the cost of British art is still comparatively modest compared to the international stars such as Jasper Johns, say, or Anselm Kiefer, it has still risen astronomically. Even a decade's worth of CAS purchase funds could not now rise to the purchase of a Francis Bacon, although by the end of the 1980s the CAS was spending well over £100,000 per annum on direct purchasing for public collections.

Installation, for which there has been almost a vogue, is understandably difficult both for galleries and the CAS. Charles Saatchi indeed purchased and has now twice displayed Richard Wilson's 20:50. A gallery such as Matt's is a pioneer in the field; subsidized exhibitions like 'The British Art Show' of 1990 (South Bank) can also show installation.

Jock McFadyen b.1950
Watney Market 1985
oil on canvas, 213.2 × 152.5 cm
purchased by Stephen Tumim, 1986
presented to Edinburgh Arts Centre, 1988

Paula Rego b.1935
The Vivian Girls 1984
acrylic on paper, 121.9 × 152.4 cm
purchased by Mary Rose Beaumont, 1985
presented to Bristol City Art Gallery, 1988

So the CAS has, by and large, concentrated on more conventional art, in so far as it has purchased objects, and counted on its prescience, and the individual taste of its buyers, to produce what overall would be seen as an accurate reflection of the most interesting work being produced in the Britain of the 1980s: a decade that was culturally alive, looking both across the Atlantic and across the Channel, yet producing art inimitably native. The debate between the avant-garde, the conservative avant-garde, and the just plain conservative was also lively and occasionally virulent. Peter Fuller, founder-editor in 1988 of a periodical called *Modern Painters* (after the book by his hero, John Ruskin), and a national newspaper contributor in the late 1980s, before his untimely death in a car accident in the spring of 1990, backed an art of national character, almost invariably representational. He was particularly attached to the work of such artists as Graham Sutherland, David Bomberg, Leon Kossoff, and reserved special vitriol for artists such as Richard Long, Gilbert & George, and Francis Bacon. His views, perhaps those of a romantic reactionary, were widely held by a large art audience, but were probably quietly opposed by the actual activities of the majority of influential curators and scholars. And, with the advent of *glasnost* and *perestroika*, Francis Bacon, and then Gilbert & George, were the 'advanced' British artists first shown in Moscow, in spite of, or perhaps because of, their art, which could often express a kind of intense despair about the human condition.

The purchases of the CAS were across the divide, as eclectic and pluralist as the art of the decade, taking no sides but even-handedly and individually seeking indefinable quality, that sense of what made an object, regardless of scale and size, something that could and should go on public view.

Moreover, the CAS also purchased across the board, in the main defying categories. A specialist craft buying policy was formally instituted in 1983, initially backed by the Crafts Council, but as early as 1980 bowls by Lucie Rie were being purchased. Prints and works on paper figured large, partly because of personal preference and interest, partly because in the occasionally unfathomable hierarchy of the fine arts, works on paper tend to cost less than paintings by the same artist. Owing to a grant from the Scottish Arts Council specific buying from Scotland was also stressed, well in advance of the national interest in contemporary Scottish art. Thus, again in 1980, outstanding purchases of work by Scottish artists included John Bellany's painting, *Celtic Conversants*, and Will Maclean's box construction, *Window Visitation, North Uist*. Not only does the CAS buy, but it is a conduit for gifts and bequests; one such, from Nancy Balfour, again as early as 1980, was the oak sculpture *Arch* by David Nash, an artist who has gone on to achieve a substantial international reputation.

The CAS by practice has tended to buy British, although, as we have seen in

earlier times, a few buyers looked to the foreign avant-garde. Thus it was a breath of fresh air when, highly unusually, Alan Bowness emphasized American and European art in his purchases for 1981, including Jennifer Bartlett, Sandro Chia, Francesco Clemente, Sol LeWitt, Markus Lupertz and Claude Viallat in his CAS acquisitions. Again, though, his list stressed how to buy early: Tony Cragg's witty, elegant *Union Jack*, 1981, of blue and red plastic objects, was purchased by Alan Bowness almost as soon as it was finished, and has been continually borrowed and shown internationally ever since. Alan Bowness, then Director of the Tate, was able to inject an unusually broad view into the CAS thinking.

Others bought as early as 1981, whose reputations have continued to expand, include Bruce McLean, John Walker and Hugh O'Donnell (now among the many British artists who live and work on the American East Coast). Gifts in

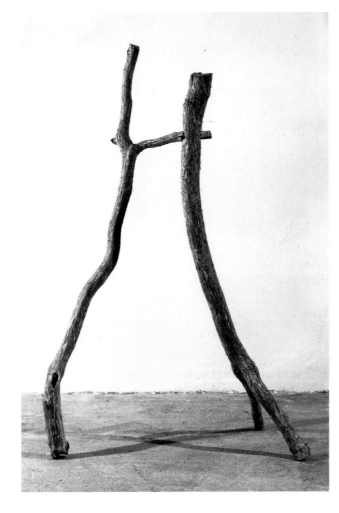

David Nash b.1945
Arch 1979
oak, 215.2 × 152.3 × 77.4 cm
presented by Nancy Balfour, 1980
presented to the Art Gallery of
Western Australia, Perth, 1982
© David Nash 1991
All Rights Reserved DACS

[139]

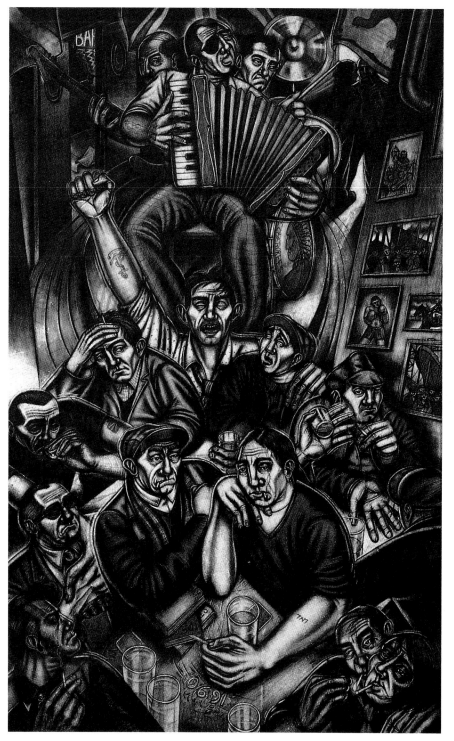

Ken Currie b.1960
In the City Bar ... Disillusion 1985
Conté pencil on paper,
239 × 152.4 cm
purchased by David Brown, with the
aid of a grant from the Scottish Arts
Council, 1986
presented to Leeds City Art Gallery,
1988

Gillian Ayres b.1930
Florestan 1986
oil on canvas, 137 × 137 cm
purchased by Caryl Hubbard, 1987
presented to Swindon Art Gallery, 1988

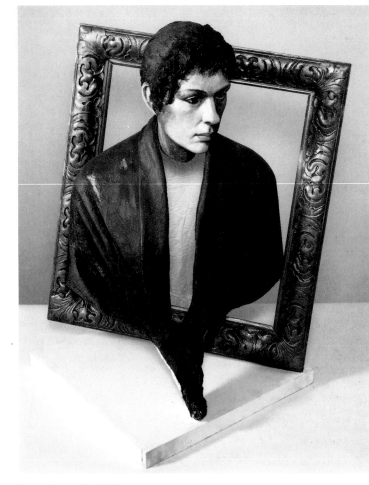

Rose Garrard b.1946
Artist as Model 1982
acrylic on plaster in gilt frame, 78.7 × 61 × 53.3 cm
purchased by Muriel Wilson, 1983
presented to Harrogate Art Gallery, 1986

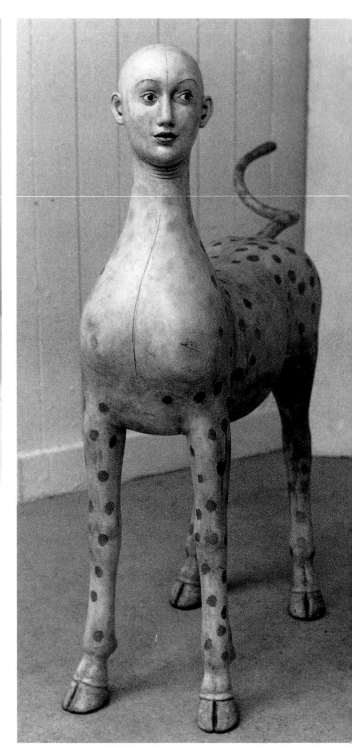

Dhruva Mistry b.1957
Creature 1983
plaster, iron, shellak, gold leaf, acrylic, 156 × 151 × 40 cm
purchased by Jeremy Rees, 1984
presented to the Ulster Museum, Belfast, 1986

1981, an outstanding year, included twenty-eight paintings and drawings by David Bomberg from Mr and Mrs J. Newmark.

The CAS does try to sustain an interest in an artist, so that more than one purchase may be made, even in succeeding years. Gilbert & George figure both in 1982 and 1984; another Bruce McLean was added in 1982; and such established artists as Roger Hilton – a 1974 gouache bought in 1982, for example – were not neglected.

By 1983, the first Richard Deacon purchase was listed, not to mention such imaginative purchases as those of both Julian Opie and Lisa Milroy, and Alison Wilding, more or less at the start of their careers, all these among the lists of Muriel Wilson of the British Council. Although everybody on the CAS is appointed personally, representing no institution, the broad view and connections of an exhibition organizer and purchaser like Mrs Wilson are characteristic of the invaluable individual contributions made in a system that encourages individual taste, even adventure.

In 1983, the Henry Moore Foundation initiated the first of its donations to help specifically with the acquisition of sculpture: the Richard Deacon mentioned above, and David Mach's exceptionally witty *Thinking of England*, 1983 (HP sauce bottles filled with coloured water to make a pattern of the Union Jack, much borrowed!) were collected. Anish Kapoor was another Henry Moore funded purchase (1984), and Scottish buying included Steven Campbell in that same year. Boyd Webb entered the collection also in 1984, as did Stephen Farthing and Dhruva Mistry, all three bought by Jeremy Rees, then Director of the Arnolfini, Bristol.

Paula Rego and Ana Maria Pacheco entered the CAS lists in 1985, a year which included another rare foreign purchase, a gouache by the German K. H. Hodicke. The same year saw the beginning of a partnership between a provincial collection, the Harris Museum and Art Gallery, Preston, and the CAS, with backing from the Arts Council, to purchase collaboratively specifically for the Harris. The first year included Ian McKeever, Thérèse Oulton, and an important sculpture by Michael Sandle.

By 1986, David Brown, with his intimate knowledge of Scotland, had bought the much discussed precocious Stephen Conroy from his Glasgow School of Art showing, as well as Ken Currie and Peter Howson; Stephen Farthing, Gillian Ayres, Stephen Buckley, Dhruva Mistry and more Eileen Agar, were among the other artists represented. In 1987, a major work by John Keane, *Bee-Keeping in the War Zone*, painted that year, was purchased by the then Chairman of the CAS, Caryl Hubbard (trustee of the Tate and the National Galleries, and instigator of the CAS Market, for which the CAS received a National Art-Collections award in 1988). Leon Kossoff, Richard Deacon and Thérèse Oulton were among the artists

John Keane b.1954
Bee-Keeping in the War Zone 1987
oil on canvas, 192 × 167 cm
purchased by Caryl Hubbard, 1987
presented to Cleveland Gallery, 1988

to receive continuing support, and the remarkable photopieces of Calum Colvin and Ron O'Donnell also entered the CAS lists.

By 1988, the Henry Moore Foundation provided the wherewithal to purchase an Alison Wilding and a Stephen Cox, craft buying proceeded apace, a Prunella Clough was purchased in 1989, as well as two Ian Davenports. This much-lauded recent Goldsmith's graduate was the only new young painter to be taken on by Leslie Waddington's gallery in the 1980s.

Other young artists whose work entered the CAS lists in the 1980s included Lucy Jones, Ansel Krut, and Veronica Ryan. Overall, purchases have probably included more women than is usual in institutional and committee buying; more works on paper; and are intensely varied, although certain artists are purchased every other year or so. It is difficult, from a London vantage point, to remember how intensely straitened most purchasing of contemporary art for public collections outside London actually is. The CAS is not only a major factor in helping with such collections, but also acts as collaborative eyes and ears in an increasingly complicated and interesting art world.

The increasing concern for sculpture, for craft, and the emergence of some of the artists mentioned above as important figures, and the early recognition by the CAS of individual promise – and achievement – are characteristics of the 1980s. It was a decade of hype, but also a period when British art-making diversified as never before, and reached new heights.

The Contemporary Art Society record; what they bought well, and what they missed Edward Lucie-Smith

Like so many of the better things in British cultural life, the CAS – founded by Roger Fry and Lady Ottoline Morrell – was a product of the Bloomsbury ethos. It was therefore natural that it should, from its beginnings, show a preference for Bloomsbury-connected artists. These also fitted into the general theoretical framework about the evolution of a new modernist spirit which Fry and his close colleague Clive Bell were elaborating in their critical writings. It is nevertheless possible to feel that, during at least the first thirty years of its existence, the CAS buyers carried Bloomsbury clan loyalty to extremes. Works by Duncan Grant and Vanessa Bell were bought more regularly than those of any other artists. Mark Gertler was another favourite, until his suicide in 1939.

Acceptable alternatives to actual denizens of Bloomsbury were artists who belonged to the Camden Town School; presumably this was so thanks to their close connection with French Impressionism. The Society bought Sickert – its first example was one of its best early purchases, the well-known *Ennui*, now in the Tate, purchased in 1914. It also acquired works by Charles Ginner and Spencer Gore. It neglected Robert Bevan, presumably on the grounds that he was 'amateurish'. The only Bevan ever purchased by the CAS was a lithograph, presented to the Victoria and Albert Museum in 1937.

By contrast, the CAS had little to do with the Vorticist Movement, which Roger Fry in particular had good reason to regard as a nest of enemies. In its earliest days, the CAS took on a work by Epstein as a gift. In 1916, in the middle of World War I, when Vorticism was effectively already over, it acquired C. R. W. Nevinson's *La Mitrailleuse*, still perhaps the artist's best-known image. Buyers avoided Vorticist Bomberg, but finally purchased a landscape in 1931 – a painting from his most conservative period. Subsequently the CAS neglected this member of the awkward squad until his death. Representation of Bomberg in the Society's roster of acquisitions was transformed only recently, in 1981, thanks to the gifts from Mr and Mrs J. Newmark. A Vorticist painting by Wyndham Lewis was finally acquired in 1938 (but there were gifts of drawings in 1923 and 1926, and pre-Vorticist acquisitions earlier, see p.32). The artist whom buyers forgave most readily for his association with Vorticism was William Roberts – *Head of a*

David Bomberg 1890–1957
Self Portrait c.1930
charcoal on paper, 48.3 × 27.9 cm
Presented in memory of David Bomberg by Mr and Mrs J. Newmark,
through the CAS, to the Towner Art Gallery, Eastbourne, 1981

[147]

Woman was bought in 1920, *Red Turban* in 1922 and *The Dance Club* in 1925. After this there was a gap, but post 1940, Roberts became quite popular with CAS buyers.

They were almost equally cautious in their approach to Stanley Spencer. Kenneth Pople's biography reveals that Spencer's early masterpiece, *Apple Gatherers*, was seriously considered for acquisition when it was first painted, but that the purchase was blocked by Clive Bell, who felt that the work was not in accordance with his own critical principles. It was subsequently acquired by that impassioned collector Edward Marsh, who presented it to the Tate in 1946. Through Marsh's 1953 bequest the CAS acquired a drawing of the same subject.

In 1921 the CAS bought *Christ carrying the Cross*, then nothing more until the early 1930s, soon after the completion of the murals in the Burghclere Chapel, which established Spencer as being without any question a major artist. What they chose was bland – two of Spencer's less personal, more conventional works. One possible factor in all this was Spencer's involvement with Patricia Preece, who was to become his second wife – this began in 1929. Preece was something of a Bloomsbury favourite, having been a pupil of Roger Fry and at the Slade. However, as she bluntly told Maurice Collis, Spencer's first biographer, she disliked all of her husband's work.

During the 1930s there was a slow revival of the avant-garde spirit in Britain. The new art of the period took forms which were reasonably sympathetic to those brought up in the Bloomsbury tradition, who still instinctively thought of France as the place where the pioneering spirit expressed itself most forcefully. The CAS acquired its first Ben Nicholsons in 1931: here, at least, was an experimental artist whose affinities with the *Ecole de Paris* were obvious. It bought more Nicholsons in 1933 and 1934, and also an Edward Wadsworth in 1933.

One of the great gaps in its acquisition list at this time was, and to a large extent remained, Nicholson's second wife, Barbara Hepworth. The first and only Hepworth ever bought by the CAS was a pencil drawing, acquired as late as 1950. The first Henry Moore came in 1939, by which time Moore was already a considerable figure in British art, though he had not as yet made an international reputation.

The appearance of the Euston Road School in the 1930s can be interpreted as a form of conservative backlash – a milder version of what was happening contemporaneously in western Europe, in Russia, and even in the United States. It seems to have been greeted by the Society's buyers with something resembling a sigh of relief. They hastened to buy works by Graham Bell, Lawrence Gowing and Victor Pasmore. Surprisingly, the William Coldstreams it acquired came not as purchases but as gifts. In 1931, at the very start of Coldstream's career, Edward Marsh presented the CAS with *The Giraffe House*. Fifteen years later, Sir Kenneth

Clark gave it the *Portrait of Mrs Auden* (the formidable mother of the poet), which had been painted a decade earlier. That is, the CAS did not take on Coldstream at the period when he was having his greatest impact on British art. Nor did it patronize him afterwards. When a third Coldstream came to the Society it was through the Marsh legacy of 1953.

The buyers responded more eagerly to the rise of British Neo-Romanticism. Graham Sutherland was purchased in 1938, John Piper soon followed; Robert Colquhoun was bought in 1942, and Cecil Collins the following year. John Minton, John Craxton, Merlyn Evans, Lucian Freud and Ceri Richards were all bought in the late 1940s.

To other, more isolated artists the response was far more hesitant. A case in point is William Scott, first purchased in 1948. He had by this time already had two solo exhibitions in London, at the Leger Gallery in 1942 and 1945. The CAS's slow response was the more surprising since Scott's early work is in the slightly French idiom which its buyers had always liked. It is easier to understand their

Lucian Freud b.1922
Still Life with Sea Urchin 1949
tempera on panel
30.8 × 24.7 cm
purchased by Robin Ironside, 1950
presented to the Harris Museum and Art Gallery, Preston, 1952

reticence when faced with Edward Burra. Burra's finest work was done in the 1930s. The Royal Academy's 1987 survey exhibition, 'British Art in the 20th Century', included eight works by Burra, all dated between 1929 and 1938. Burra himself had his first really major show – a partial retrospective – at the Redfern Gallery in 1942. The CAS did not purchase an example until ten years later. There may have been several reasons: the fact that Burra worked only in watercolour was perhaps one of them. There was also his somewhat eldritch personality, and, in the early work, his louche subject matter. However, this was clearly a chance the Society missed.

It did not miss the opportunity to buy Francis Bacon. Its first Bacon was bought in 1946. The promptitude of the purchase, which came very soon after the artist's emergence, is in itself a measure of Bacon's initial impact on the then very small London art world. This purchase was followed by others – *Head II*, now in Belfast, and *Pope I*, in Aberdeen. The latter was purchased in 1952, and after this Bacon soared beyond the Society's capacity to buy. Of all the works the Society has purchased, these three Bacons are probably the most valuable today.

The late 1940s, the 1950s and the early 1960s now look like a golden age for the CAS. Its buyers were able to patronize most of the important British artists and art movements of the time. To the Neo-Romantics and Bacon were soon added works by the Kitchen Sink School – first a Bratby, *Still Life with Chip Fryer* (bought in 1954, and how evocative the subject matter now seems). This was followed by a Jack Smith (1956 – the year Smith, Bratby and Middleditch were all shown in the British pavilion at the Venice Biennale), then another Bratby in 1957. The CAS has remained faithful to Jack Smith through all his subsequent changes of style.

CAS buyers also noted the emergence of the postwar St Ives School – Peter Lanyon's *Porthleven* was acquired in 1951. They continued to be well informed about new developments throughout the 1950s. In 1959 they had a particularly good year. The Society acquired Peter Blake's *On the Balcony*, a seminal work in the development of British Pop Art, plus an early painting by Richard Smith which combined Pop and abstract elements, and a typical Situation Group abstract by Harold Cohen. For their period, these were all works very much on the cutting edge.

In 1963, there was another series of coups – a major early painting by David Hockney, *The Marriage of Styles No. 2*, plus a Frank Auerbach and a Howard Hodgkin. A Leon Kossoff was added to the list in the following year.

Enthusiasm for Howard Hodgkin may have been due, in part at least, to a kind of atavism; strong Bloomsbury overtones have always been present in his work. The Society bought his paintings so often in the 1960s and 1970s that

during this period he became a kind of equivalent for Duncan Grant and Vanessa Bell at an earlier time. Five Hodgkins were bought between 1963 and 1978. After that his work, like that of Bacon and Hockney before him, soared out of reach financially.

The 1970s was a less happy time for CAS buyers than the 1950s and 1960s. In 1972 the Arts Council staged an exhibition at the Hayward Gallery, boldly entitled 'The New Art'. The artists included were mostly Conceptualists. The list was as follows: Keith Arnatt, Art & Language, Victor Burgin, Michael Craig-Martin, David Dye, Barry Flanagan, Hamish Fulton, Gilbert & George, John Hilliard, Richard Long, Keith Milow, Gerald Newman, John Stezaker and David Tremlett. Some of these have never attracted the Society's attention at all. To others it came only rather reluctantly. With one alone it was ahead of the game – Barry Flanagan was first bought in 1969. Keith Milow followed in 1972 and 1974, and Michael Craig-Martin in 1975. Richard Long, one of the great art-heroes of his period, did not arrive until 1981. Hamish Fulton and Gilbert & George had to wait until 1982.

The difficulty for CAS buyers, when confronted with art of the type featured in the Hayward show, was often the fact that it was not physically concise. It was

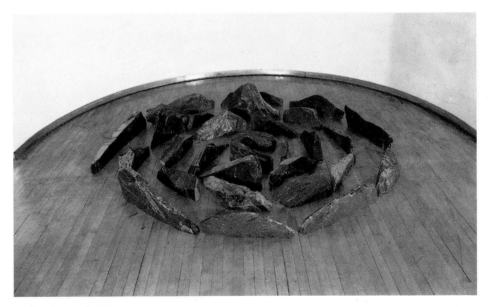

Richard Long b.1945
Delabole Spiral 1981
28 stones, diameter approx. 152 cm
purchased by Alan Bowness, 1981
presented to Graves Art Gallery, Sheffield, 1982

not simple to display, nor even to store, and the materials used were often far from conventional. It thus did not seem to meet museum needs, and at the same time seemed likely to arouse curatorial prejudices.

CAS buyers did, nevertheless, show an awareness of the change in aesthetic climate which took place in the 1970s. They bought many more abstract works, but preferred them to be in reasonably conventional formats. One important artist whom they netted early, before his departure for the United States, was Sean Scully, purchased in 1973.

The 1980s offered a plurality of choices and opportunities. The buyers responded eagerly to a new generation of figurative artists – Maggi Hambling, Stephen McKenna, Tony Bevan, John Keane. They took an interest in young Scottish painters – Steven Campbell, Ken Currie, Peter Howson and Gwen Hardie. They anticipated the boom in reputation (and price) which overtook another very young Scottish artist, Stephen Conroy. They were well informed about the new British sculpture. Tony Cragg, perhaps the most conspicuous member of his sculptural generation, was bought in 1981, and other acquisitions included work by Richard Deacon, David Mach, Julian Opie, Anish Kapoor, Dhruva Mistry, and Shirazeh Houshiary.

The one conspicuous omission here was the stone-carver Glynn Williams. This highlights one feature of recent purchasing which is less creditable to the CAS – a certain trendiness, a fear of not being in the swim. Williams, who reverts to some of the ideas and forms of early Epstein, has been regarded by important critics – notably the late Peter Fuller – as a seminal force in recent British art. Others have seen him as a reactionary, and his work has been fiercely controversial as a result. It is the kind of controversy which should have attracted the CAS, rather than frightened it away.

Another omission from the list of acquisitions during the 1980s is any typical work by Michael Leonard. In 1980 the CAS bought a fairly early painting, *Boy in a Dinghy*, using part of a grant from The Worshipful Company of Painter-Stainers. It has never bought one of the paintings Leonard is now best known for – his male and female nudes.

In general terms the CAS's relationship with the British art scene shows admirable catholicity of taste. Its weakest spot, till very recently, was art north of the border. The Scottish Colourists of the earlier part of the century never attracted CAS buyers – a J. D. Fergusson was presented in 1928 and an S. J. Peploe in 1944. The latter came from S. E. Thornton. Other Scots were purchased grudgingly and late – two William Gillies watercolours, presented to Bradford and Liverpool respectively in 1948; two William Johnstones (1957 and 1979), both of which went to Scottish galleries; a William MacTaggart bought in 1958.

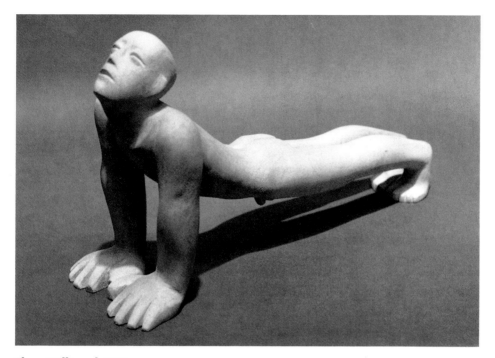

Glynn Williams b.1939
Stone Bridge No. 2 1988
Ancaster stone
48.3 × 26.7 × 15.2 cm
Private collection, courtesy of Bernard Jacobson Gallery

One surprising omission is Anne Redpath, who was never purchased by the Society.

The one Scottish artist previous to the 1980s who contrived to impress the Society's buyers without the help of London residence or strong gallery representation in London was Ian Hamilton Finlay. The CAS bought one work in 1969, three in 1977 and a fourth two years later.

In the 1980s, however, the situation completely changed, first because of a grant from the Scottish Arts Council, specifically for the purchase of contemporary Scottish art; secondly because of the worldwide celebrity of the so-called Glasgow Brats, Steven Campbell and others. The CAS's purchases of work by artists in this group have already been referred to.

When seeking new members and additional funds, the CAS has on occasion tended to make much, not of its record as a buyer of British art – though Bacon and Hockney have inevitably been mentioned – but of its skill and prescience in

buying great names from abroad. This claim does not sustain close examination.

During its first decade the Society purchased, not Blue Period Picasso, Fauve Matisse or works by the Nabis, but a Gauguin already more than a decade old and three works by Lucien Pissarro, an English-domiciled French artist who was a pale shadow of his Impressionist father. In the 1920s, in addition to two Gauguin drawings, it acquired a Degas drawing, a Vlaminck watercolour, a Picasso drawing, and then, but only in the second half of the decade, paintings by Vuillard, Rouault and Matisse, plus a Matisse drawing. All of these can safely be regarded as totem objects, accurate reflections of the taste of Roger Fry and his ally Clive Bell.

In the early 1930s, enthusiasm for foreign art diminished. There was, however, one major buy – a Picasso painting which cost £700 (a very large sum at the time – half was contributed by the NACF). Apart from this the only foreign purchases were a Signac watercolour and another Vlaminck drawing, though Lord Ivor Spencer-Churchill gave two paintings by Bonnard. The pattern was maintained in the second half of the decade. Three works on paper by George Grosz were donated by Grosz's dealer, Alfred Flechtheim, by then an émigré, as was Grosz himself. The gift may have been an attempt to help this typically Weimar draughtsman root himself in another cultural world. The CAS, of its own volition, bought four cartoons for the Diego Rivera murals in Detroit. This purchase, one guesses, was a reflection of the new left-wing consciousness in English intellectual circles. The experiment with Latin American art was never repeated.

During the war years a painting by Max Ernst was acquired as a gift, and a Klee was purchased. In 1949 came an acquisition which was far more significant in terms of the history of taste: the CAS bought Giacometti's *Portrait of the Artist's Mother*. This marked the beginning of the long English romance with the artist's post-Surrealist work. Another postwar buy was a painting by the veteran French Surrealist André Masson. Interestingly, the CAS never paid much attention to the native British Surrealists.

The 1960s began with a brief flurry of enthusiasm for the new Australian art – a Sidney Nolan, an Arthur Boyd and two Brett Whiteleys. Whiteley was then living in London and enjoying a success which paralleled and indeed anticipated that of David Hockney. The only other major foreign purchase of the decade was a Helen Frankenthaler of 1965. The CAS never bought even the most minor example of American Abstract Expressionism, nor of American Pop Art, and Frankenthaler was its one venture into Clement Greenberg-blessed Post Painterly Abstraction. One very odd omission among American artists was the London-based R. B. Kitaj. The CAS's sole purchase is a screenprint, bought in 1978.

[154]

Alberto Giacometti 1901–66
Portrait of the Artist's Mother 1949
oil on canvas, 73.7 × 38.1 cm
purchased by CAS Foreign
Fund sub-committee, 1949
presented to Manchester City
Art Gallery, 1952
© ADAGP, Paris and DACS, London

[155]

In general, foreign purchases throughout the 1970s were fairly thin on the ground. One buyer who made an effort in this direction was the late Max Gordon, who in 1974 bought a series of prints by American Minimalists and Conceptualists. In the early 1980s the focus shifted to German and Italian Neo-Expressionists, with works by the Germans A. R. Penck and Markus Lupertz and by the Italians Sandro Chia and Francesco Clemente. The most important of these was a painting by Lupertz, which soon thereafter found its way to Sydney. In recent years the foreign artists who have won favour have almost invariably been British residents and fully integrated with the current British art scene. Examples are Paula Rego and Ana Maria Pacheco.

The verdict must be that the buyers are nearly always heavily dependent on what is available in London galleries at a given moment. They have never really tried to buy abroad. When important foreign artists are shown in London they are nearly always well beyond the Society's price-range, if not beyond the buyers' range of sensibility.

If one looks back at the whole history of CAS purchasing, one recognizes a certain consistency of attitude. Its buyers have seldom been genuinely 'ahead of the game', but they have been extremely sensitive to movements in taste. They have seldom missed any British art movement completely – even the leading British Minimalists, producing the sort of art to which most CAS buyers were unlikely to be sympathetic, were singled out for purchase (perhaps just a trifle belatedly) in the course of the 1980s. A Bob Law maquette and a work by Alan Charlton were bought in 1985, and a Peter Joseph in 1989. Another Peter Joseph was in fact purchased as early as 1966.

For purely financial reasons, works by major artists – Hockney and Bacon for instance – have nearly always been bought early in their careers. Late Hockney and late Bacon have always been well beyond the Society's reach. So, too, have the mature works of Lucian Freud and recent paintings by Kossoff and Auerbach. A buyer who leaps in and grabs the work of a promising newcomer may be doing so on the basis of knowledge, or more likely of gut instinct. Or else he or she may simply be caught up in the kind of feeding frenzy which occasionally seizes a substantial section of the British art world. On the whole the buyers have got matters right far more often than they have got them wrong. From the standpoint of 1991 they have bought many more good works of art than bad ones. Where British art is concerned, while they have bought some good artists rather late, there are very few whom they have neglected altogether.

Contemporary Art Society Committee Members 1910–1991

Charles Aitken 1910–31
Clive Bell 1910–17
Lord Henry Bentinck 1910–31
Arthur Clutton-Brock 1910–23
Sir Augustus Daniel 1910–45
Campbell Dodgson 1910–45
Judge Evans 1910–c.1913
Roger Fry 1910–34
Sir Cyril Kendall-Butler 1910–36
D. S. MacColl 1910–13
Ernest Marsh 1910–44
Lady Ottoline Morrell 1910–c.1915
Philip Morrell 1910–c.1913
J. Bowyer Nichols 1910–c.1913
The Earl of Plymouth 1910–23
The Lord Ribblesdale 1910–c.1914
Frank Rinder 1910–23
Robert Ross 1910–17
The Hon. Gervase Beckett 1912
Geoffrey Blackwell 1914–28
Edward Marsh 1917–53
St John Hutchinson 1918–42
Muirhead Bone 1920–46
Mrs Campbell Dodgson 1923–6
Roderick Meiklejohn 1923–30
The Hon. Jasper Ridley 1923–51
Michael Sadler 1923–43
Samuel Courtauld 1924–48
The Rt. Hon. F. Leverton Harris 1924–6
The Earl of Sandwich 1924–46
Sir Philip Sassoon 1924
The Earl of Crawford and Balcarres 1927–38, 1941–9
Anthony Eden 1927–31
Montague Shearman 1927–40
Lord Ivor Spencer-Churchill 1927–49
J. B. Manson 1930–42
Ernest Gye 1932–3
Maynard Keynes 1932–46
C. L. Stocks 1932–45
A. M. Hind 1935–46
Kenneth Clark 1937–53
Thelma Cazalet 1938–56

John Rothenstein 1938–65
T. E. Lowinsky 1943–6
Colin Anderson 1945–65
Edward le Bas 1945–56
Vincent Massey 1945
Raymond Mortimer 1945–65
Lady Sempill 1945–9
Alan Ward 1945–9
Philip Hendy 1946–57
Robin Ironside 1946–52
The Lord Methuen 1946–53
W. A. Evill 1947–57
E. C. Gregory 1947–58
Eardley Knollys 1947–66
Hugo Pitman 1948–54
A. E. Popham 1949–54
Howard Bliss 1950–7
Loraine Conran 1951–70
Eric Newton 1951–65
Peter Meyer 1953–66, 1967–76
Derek Hill 1956–67
Dr Alastair Hunter 1956–65
Anthony Lousada 1956–71
Mrs Oliver Parker 1956–65
Bryan Robertson 1957–67, 1968–73
The Hon. Michael Astor 1958–68
Whitney Straight 1958–71
John Sainsbury 1959–74
Alan Bowness 1961–9, 1970–5, 1976–86
The Lord Croft 1961–8, 1970–81
James Melvin 1961–9
Elizabeth Heygate 1962–6
Dr Kenneth Marsh 1963–70
Justin Knowles 1965–6
Norman Reid 1965–72, 1973–7
David Sylvester 1965–70
David Thompson 1965–72
Nancy Balfour 1967–82
Joanna Drew 1967–73, 1975–83
Alistair McAlpine 1970–80
Alexander Dunbar 1971–4
Carol Hogben 1971–5, 1976–85
Max Gordon 1972–7

Caryl Hubbard 1972–88
Marina Vaizey 1973–9, 1980–
Neville Burston 1974–6
Anthony Diamond 1974–9
Edward Lucie-Smith 1974–80, 1981–90
Norbert Lynton 1974–8
Peter Moores 1974–8
Catherine Curran 1975–83
The Marquess of Dufferin and Ava 1975–83
Gabrielle Keiller 1975–81
Bryan Montgomery 1976–84
Geoffrey Tucker 1976–84
David Brown 1977–87
William Packer 1977–87
Belle Shenkman 1977–86
Ann Sutton 1977–87
Robin Campbell 1978–82
Muriel Wilson 1978–88
Edward Dawe 1979–86
Mary Rose Beaumont 1981–9
Ronnie Duncan 1981–9
James Holloway 1981–5
Jeremy Rees 1981–
Alan Roger 1981–90
David Cargill 1982–7
Stephen Tumim 1982–
Philip Pollock 1983–
Tom Bendhem 1984–
The Marquess of Douro 1985–9
Sir Michael Culme-Seymour 1986–
Robin Woodhead 1986–
Richard Morphet 1987–
Robert Cumming 1988–90
Rupert Gavin 1988–
Penelope Govett 1988–
Christina Smith 1988–
Adrian Ward-Jackson 1988–
John Keatley 1989–
Sebastian Walker 1989–91
Cecily Lowenthal 1990–
Anthony Oppenheimer 1990–
Julian Treuherz 1990–
Sarah Wilson 1990–
Mark Stephens 1991–

Photographic Acknowledgements

Numbers refer to pages on which illustrations appear.

Other photographs were supplied by the institutions mentioned in the captions

[handwritten: all the other galleries the now could bein.]

Index of Artists

*Figures in **bold** type refer to pages on which illustrations appear.*

Rauerberg
7↑
Richas.
1 49.